THE ART OF DAILY LIFE

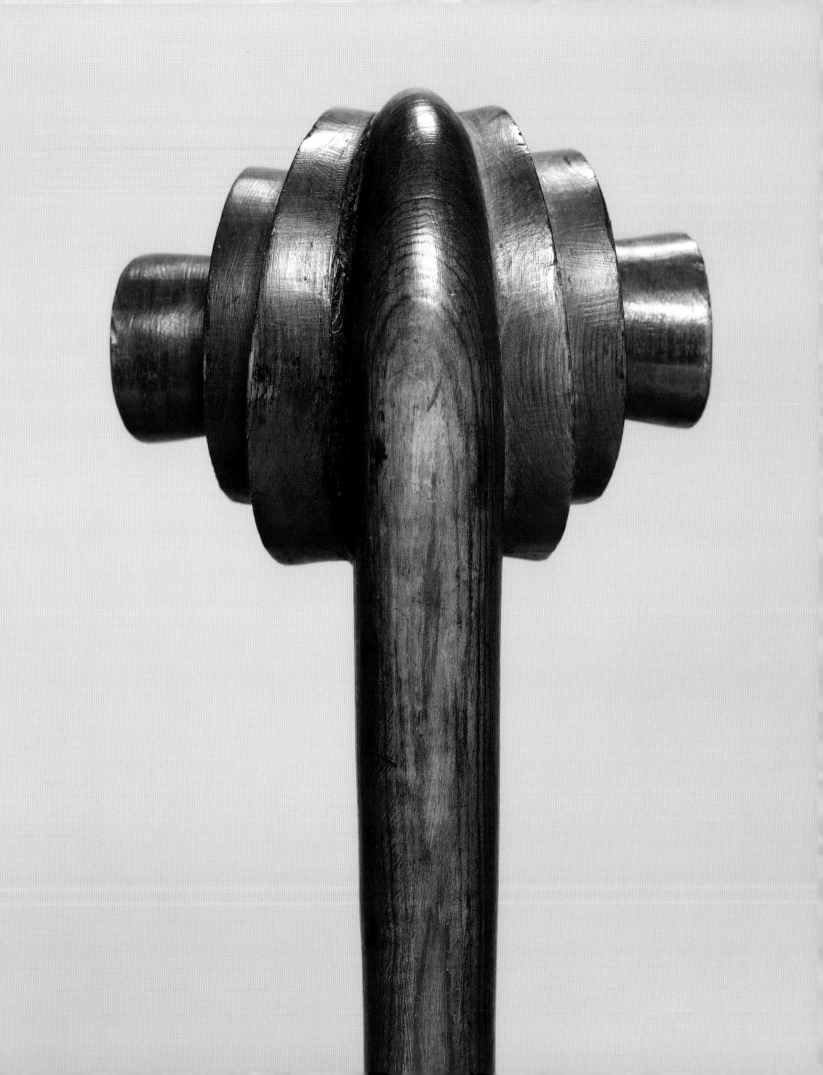

CONSTANTINE PETRIDIS

THE ART OF DAILY LIFE

PORTABLE OBJECTS FROM SOUTHEAST AFRICA

with an essay by Karel Nel

 THE CLEVELAND MUSEUM OF ART

Published on the occasion of the exhibition *The Art of Daily Life: Portable Objects from Southeast Africa*, April 17, 2011–February 26, 2012, at the Cleveland Museum of Art.

THE CLEVELAND MUSEUM OF ART
Editing: Barbara J. Bradley, Amy Bracken Sparks
Map: Carolyn K. Lewis

5 CONTINENTS EDITIONS
Editorial Coordination: Laura Maggioni
Art Direction: Annarita De Sanctis
Production Manager: Enzo Porcino

Color Separation: Pixel Studio, Milan

Printed in Italy in January 2011
by Grafiche Flaminia, Foligno (PG)

Library of Congress Control Number: 2010939997
ISBN: 978-1-935294-03-0
(The Cleveland Museum of Art)
ISBN: 978-88-7438-578-1 (5 Continents Editions)

Distributed in the United States and Canada
by Harry N. Abrams, Inc., New York. Distributed
outside the United States and Canada, excluding
France and Italy, by Abrams & Chronicle Books
Ltd UK, London.

www.clevelandart.org
www.fivecontinentseditions.com

The Cleveland Museum of Art gratefully
acknowledges the citizens of Cuyahoga County
for their support through Cuyahoga Arts
and Culture. The Ohio Arts Council helps fund
the museum with state tax dollars to encourage
economic growth, educational excellence,
and cultural enrichment for all Ohioans.

This publication is made possible by
The Andrew W. Mellon Foundation.

PAGE 2: *Knobkerrie* (rear view) (cat. 46)
PAGE 8: *Staff* (cat. 55)

PHOTOGRAPHY CREDITS
ArtDigitalStudio, Paris, courtesy Sotheby's, Paris:
cats. 11, 20; Roger Asselberghs, Brussels, courtesy
Bernard de Grunne, Brussels: cat. 57; Dirk Bakker,
courtesy Donald Morris Gallery, Michigan/New
York: cat. 4; The Cleveland Museum of Art, Gary
Kirchenbauer, photographer: front cover, frontis-
piece, page 8, and cats. 6, 10, 17, 21, 23, 31–33, 44,
46, 51, 55, 67, 71, 72, 78; Hughes Dubois, Paris/
Brussels: fig. 5; Richard Goodbody: cats. 50, 61, 68,
69, 73; Peter Harholdt: cat. 52; Robert Hensleigh:
cat. 39; Jacaranda Tribal, New York: cat. 5;
National Museum of African Art, Smithsonian
Institution, Washington, Franko Khoury, photogra-
pher: back cover and cats. 3, 12–16, 18, 19, 22, 25,
27, 34, 35; Heini Schneebeli: fig. 12; Sotheby's, New
York: cats. 49, 56; David Stansbury: cats. 75, 77;
John Bigelow Taylor: fig. 3; Jerry L. Thompson,
courtesy Museum for African Art, New York: fig. 9
and cat. 62; Benjamin Watkins: cat. 30; Bruce
White: cat. 40; Wits Art Museum, Johannesburg:
fig. 11; James Worrell: fig. 4 and cats. 1, 2, 7–9, 24,
26, 28, 29, 36–38, 41–43, 45, 47, 48, 53, 54, 58–60,
63–66, 70, 74, 76.

CONTENTS

FOREWORD

David Franklin, Director
The Cleveland Museum of Art

When I look at the objects illustrated in the following pages and admire their striking beauty and often "modern" design, it is hard to believe that this publication accompanies the first exhibition focusing on the arts of southeast Africa organized by an encyclopedic art museum in this country. Certainly, the arts of this part of the continent were well represented in *African Furniture and Household Objects*, the touring landmark exhibition Roy Sieber organized in collaboration with Cleveland native Katherine C. White for the American Federation of Arts in 1980. However, an exhibition exclusively devoted to portable objects of daily life from southeast Africa presented by an art museum like ours proves to be a first. Interestingly, the only exhibition on American soil that could be considered a precursor to our pioneering undertaking, *African Elegance: The Traditional Art of Southern Africa* (1983–84), had a strong Cleveland connection. It was on view in nearby Canton, and all of the more than 500 items on view derived from the extensive collection of Rhoda Levinsohn, a South African–born expert on the topic who happened to live in Cleveland.

What distinguishes *The Art of Daily Life* from *African Elegance*, however, aside from its size, are its multiple lenders—two museums and twenty-two private collections—and, not the least, this handsome catalogue. It has greatly benefited from the contributions of Karel Nel of the University of the Witwatersrand in Johannesburg, who wrote an enlightening essay and shared his vast knowledge with our museum's African art specialist, Constantine Petridis, who served as the exhibition's curator. Through various loans from American public and private collections, *The Art of Daily Life* celebrates the stunning formal diversity and deep cultural meanings of the rich artistic heritage of southern Africa. It introduces a wide range of personal and domestic objects created in the late 19th and early 20th centuries by highly talented artists from different pastoral cultures whose descendants inhabit present-day South Africa, Lesotho, Swaziland, Botswana, Mozambique, and Zimbabwe. The exhibition and its companion catalogue aspire to elucidate how these works were much more than exquisitely designed functional objects.

Yet, *The Art of Daily Life* also celebrates an important new development for the Cleveland Museum of Art as a collecting institution. Indeed, the museum's permanent collection of African art, like those of most of our sister institutions, was drawn heavily from West and Central Africa. Most of the masks and figures that have been recognized as "art" since the dawn of the 20th century originated in that part of sub-Saharan Africa. To this date, the peoples of the vast regions of eastern and southern Africa have created few masks and figures, and thus were hardly represented in the collection, if at all. It gives me great pleasure to inform you, however, that this past September the museum's accessions committee agreed to acquire a select group of 11 high-quality objects from different parts of southeast Africa. I take advantage of this opportunity to express my gratitude to Dori and Daniel Rootenberg, who bestowed on the museum four works in appreciation of this significant expansion of our collection. I believe it is fair to say that, as a result of these acquisitions and the added gifts, the Cleveland Museum of Art now ranks among the most important repositories of art from southern Africa in this country. I hope you will share my enthusiasm as you discover these 15 additions to our collection in the following pages. I also sincerely hope that, thanks to the efforts of Dr. Petridis and Dr. Nel, and especially the generosity of our many lenders, you will be as captivated and intrigued by the universal beauty of the works illustrated here as I was when I first encountered them.

ACKNOWLEDGMENTS

Acollaborative endeavor in the real sense of the term, many people have contributed to the successful realization of this exhibition and its companion publication. First and foremost, I would like to thank Interim Director Deborah Gribbon, Director David Franklin, and Chief Curator Griffith Mann, for their confidence. I am also grateful for the support of my colleagues in various museum departments, in particular Heidi Strean and Emily Marshall (Exhibitions), Mary Suzor and Lauren Turner (Collections Management), Jeffrey Strean, Jim Engelmann, and Andrew Gutierrez (Design), Caroline Goeser (Education), and Mary Wheelock (Development). I also thank my colleagues in the Ingalls Library, under the direction of Elizabeth Lantz, for locating and gathering countless resources. At an early stage of the organization of the exhibition, I was aptly helped in my library research by my former curatorial assistant, Lisa Simmons. In more recent months, I have enjoyed the same support from Katherine Flach, a PhD candidate in African art at Case Western Reserve University. I also owe a great debt to Barbara Bradley, director of Curatorial Publications, for her meticulous editorial work and close supervision of the production of this catalogue.

It has been a privilege to collaborate on this publication with 5 Continents Editions, Milan, and I wish to thank its founding director, Eric Ghysels. I am particularly honored to have had the chance to discuss various matters at length with Karel Nel of the University of the Witwatersrand, Johannesburg. Not only did he write an excellent essay for this publication, he generously shared his vast expertise and offered advice in the selection process. I should emphasize, however, that our tastes did not always coincide and I alone am responsible for the final choices as well as any remaining mistakes in the attribution or identification of this or that object.

Of course, the exhibition on which the catalogue is based would not have been possible without the objects, primarily borrowed from a large number of private collectors, some of whom are mentioned by name on page 111. I herewith express my sincerest thanks to all of them. My colleagues Bryna Freyer and Amy Staples deserve special mention for facilitating the 13 loans from the Smithsonian Institution's National Museum of African Art in Washington, D.C., the only other institutional lender aside from the Cleveland Museum of Art. Other colleagues who have kindly contributed in one way or another to the exhibition and/or its catalogue are: Lisa Binder and Carol Braide (Museum for African Art, New York), Jan Calmeyn (Sint-Niklaas, Belgium), Bernard de Grunne (Brussels), Els De Palmenaer (Ethnographic Museum, Antwerp, Belgium), Udo Horstmann (Zug, Switzerland), Steven Morris (Donald Morris Gallery, Michigan/New York), Fiona Rankin-Smith (Wits Art Museum, Johannesburg), James Ross (New York), Marguerite de Sabran, Alexis Maggiar, and Heinrich Schweizer (Sotheby's, Paris/New York), and Gary van Wyk (Axis Gallery, New York). My deepest gratitude, however, goes to Dori and Daniel Rootenberg (Jacaranda Tribal, New York), who benevolently acted as consultants to this project. They triggered my interest in the fascinating world of art from southeast Africa, helped shape my eye by guiding me through collections and the literature, and spared neither time nor effort to find the answers to my (too many) questions along the way.

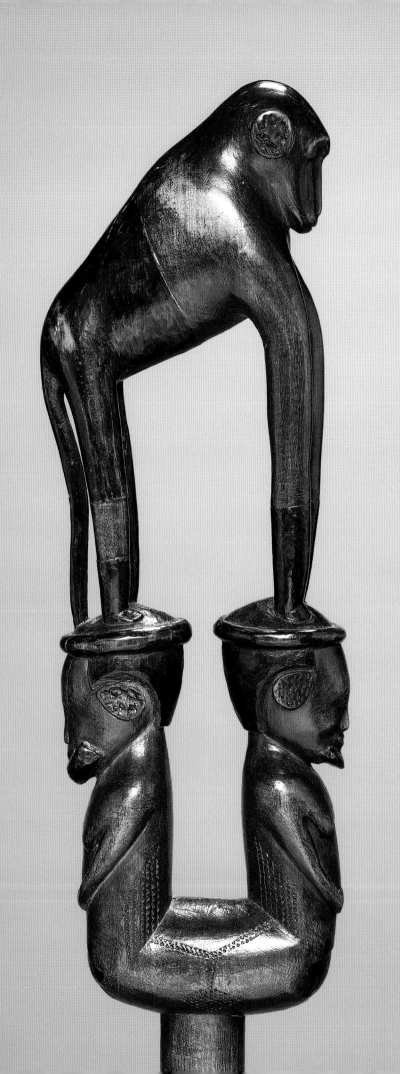

PERSONAL AND HOUSEHOLD ARTS IN SOUTHEAST AFRICA

"The exhibition attempts to show the diversity of material and to dispel the notion that little of any consequence was produced in southern Africa." Christopher Till used these words in his preface to the landmark exhibition *Art and Ambiguity* at the Johannesburg Art Gallery in 1991. This catalogue and the exhibition it accompanies share the same ambition, which is not to say that nothing has changed since 1991. Scholars generally invoke the 1995 exhibition *Africa: The Art of a Continent* at the Royal Academy of Arts in London as one of the first events to bestow worldwide recognition to southern Africa in a survey of the arts of the entire continent.[1] The London show was followed by several more focused exhibitions, among which are the monumental projects organized in Tervuren, Belgium, on Zimbabwe, and in Linz, Austria, and Paris on South Africa.[2]

In fact, with the notable exception of the Smithsonian Institution's National Museum of African Art in Washington, D.C., objects of art from southern Africa are rarely found in art museums in this country.[3] Of course, it is remarkable that our trustees had the foresight in 2010 to pursue the acquisition of 15 masterful works from the southeastern part of this vast region, elevating the Cleveland Museum of Art to one of the very few significant repositories of its kind in the United States. Yet here, too, one would hope that this is only a beginning. Compared to the fields of West and Central Africa, the research on the arts of southern Africa is still in its infancy, despite some major contributions to our knowledge over the past two decades.

The two reasons typically offered to explain this neglect are the complex history of migrations that has characterized the region for many centuries and the nature of the objects themselves—"small, domestic and personal"—that has led them to be perceived as ethnographic in nature rather than artistic (Nel 2002: 13). That argument closely follows the distinction between the categories of fine and applied art, between art and craft. Further, objects from southern Africa are ephemeral—made from organic materials that deteriorate quickly—not the durable sculptural forms of the masks and ancestor figures of West and Central Africa that have long been assimilated with the Western notion of "art." Another contributing factor is that art from southern Africa is primarily associated with beadwork (figs. 1, 2 and cats. 65–74). The paucity of scholarly sources necessary to contextualize the material only reinforced the misconception that there was no "real" art south of the Zambezi River.

Thanks to the growing research of the past few decades, and Susan Vogel's seminal theoretical discussion of the issue (Vogel 1988), however, the artificial distinction between "art" and "artifact" has been largely abandoned with regard to Africa in general (Davison 1991: 12–13; Nettleton 1991: 39). As Karel Nel's essay and the object entries in this volume amply demonstrate, viewing the objects illustrated here as merely decorative or strictly utilitarian would be a mistake. Aesthetic sensibilities are actually most often expressed in forms that integrate art and usefulness while simultaneously bridging the secular and sacred realms (Davison 1995: 180). A case in point is the ubiquitous headrest. Aside from serving as a pillow with the practical purpose of safeguarding complicated hairstyles during sleep, this type of object more often than not also functioned as a medium through which the ancestors could be contacted (Becker 1991: 74–75). Even the seemingly simple act of smoking tobacco or taking snuff had ancestral implications (Wanless 1991: 130–31). Indeed, while the objects illustrated in this publication are organized according to broad functional categories—furniture, containers, weapons, and adornment—most if not all bridge the profane and

FIG. 1. A young Zulu man wearing various beaded adornments. KwaZulu Natal, South Africa, c. 1886. From Mayr 1907.
Through compositional and stylistic comparisons, Virginia-Lee Webb determined that this photograph had been taken by George Taylor Ferneyhough (Webb 1992: 52–54).

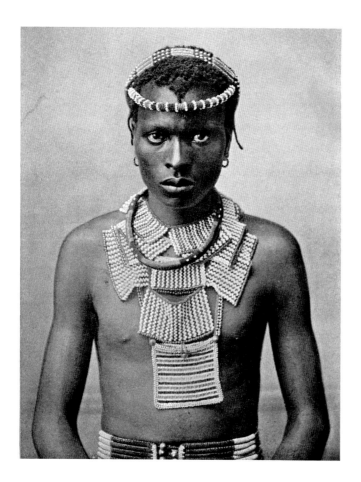

the sacred, acting as intermediaries between humans and spirits.

Yet the complex migratory history of the region persists as an impediment to understanding and appreciating its arts. Of course, this history of human interrelationships is intimately related to the semi-nomadic culture of the cattle-herding peoples who traversed the southeastern part of the African continent. This peripatetic life-style has not only contributed to the portable nature of their material culture, it has also led to their truly regional worldview and a coherent artistic legacy that transcends and defies fixed "tribal" boundaries and attributions. Indeed, the mobility that defines the history of peoples in this part of Africa also defines the history of their objects. Moreover, here, perhaps more than elsewhere in Africa, allegedly discrete ethnic identities such as Xhosa, Swazi, Sotho, or Tsonga are largely political constructs (see also Becker 2002).

The "Zulu" label that until very recently was attached to almost every object stemming from southern Africa is especially telling in this regard.[4] Although details about the specific provenance of this or that object are rarely available, most of these so-called Zulu works were collected or, rather, appropriated, during the Anglo-Zulu War of 1879. It seems the Zulu people's "powerful defiance and capacity to rally against the strength of the British Empire had so imprinted itself on the European consciousness that everything that came from the distant southern end of Africa had to be 'Zulu'" (Nel 2002: 13). As a result, many works in collections are misattributed, especially the wooden objects and early curios that were among the favorite souvenirs soldiers and early visitors brought back from their journeys.

Moreover, erroneous identification of a particular Nguni-style coiffure sometimes also resulted in a Zulu label (Nettleton 1988: 48; 1991: 38–39). One of the most cherished figurative genres from southeastern Africa, namely, carved wooden staffs or sticks surmounted with human heads or full figures, sometimes in combination with animals, suffered such a fate. This publication includes two such staffs, both attributed to the hand of an artist nicknamed the "Baboon Master" (cats. 54, 55), where a Nguni coiffure—whether the so-called headring typical of men or the peaked

FIG. **2.** A Zulu man sporting a fancy coiffure. KwaZulu Natal, South Africa, possibly late 19th century. Photographer unidentified. Postcard published by Sallo Epstein & Co., Durban. *While white observers described young Zulu men with extravagant hairdos as "dandies," people living in the Zulu kingdom referred to them derogatorily as "those with strange hairstyles" (Klopper 2000: 32).*

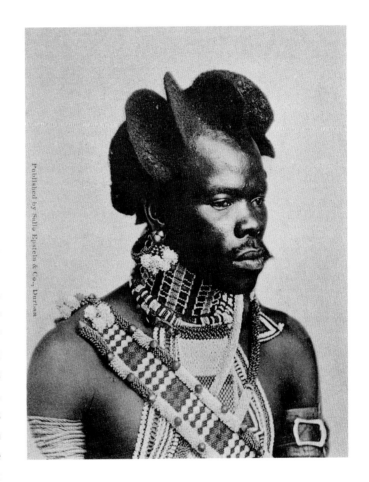

hairstyle proper to women—has conventionally been treated as a diagnostic trait of Zulu origin. In reality, however, these works were probably carved by not one but several itinerant Tsonga carvers in KwaZulu Natal (Klopper 1991: 90–97; Klopper, in Sotheby's 2005: 160). Interestingly, this question of "ethnic origin" has provoked a debate about the "authenticity" of such figurative sculpture. Following this flawed reasoning, the lack of a Nguni coiffure on a Zulu staff would have made it inappropriate for "traditional" Zulu use and naturally turned it into a piece of tourist art (Van Wyk 1994: 65).

We should also remember that the notions of "ethnicity" and its corollary "tradition" have been exploited and manipulated by the ideology of segregation that marked the apartheid regime until it was abandoned in the early 1990s (Davison 2002: 17; see also Klopper 2004: 23–24). To identify an object as "Zulu" is therefore perhaps even less innocent than the previous paragraph may suggest. It is definitely not a coincidence that the landmark exhibition *Art and Ambiguity,* which proclaimed the rich artistic heritage of southern Africa at the Johannesburg Art Gallery—the "new" country's premier temple for the arts—took place in 1991 (Schneider 1992: 93; Davison 1995: 180). The victory of the African National Congress and the election of Nelson Mandela as president of the Republic of South Africa in 1994 would further enhance the pride over "indigenous" African cultural traditions. While regional or group identities may be more accurate than monolithic ethnic labels in that they reflect the multiple, related local histories that have united the various inhabitants of the region, objects in the following pages are still accompanied by attributions attempting to connect peoples and styles. Obviously, the use of a question mark or the suggestion of alternatives in the identification of illustrated works shows that these names often remain tentative and always imply dynamic and fluid borders.

The map on page 26 locates the various peoples whose artistic creations are represented in these pages within the geopolitical reality of today. Occupying the southernmost part of the continent, what we call southeast Africa encompasses an enormous region south of the Zambezi River. The modern state of South Africa, bordered by the Atlantic Ocean to the west and the Indian Ocean to the east, and the enclave of Lesotho, are at the heart of

FIG. 3. Puppet. Possibly Tsonga people, South Africa and Mozambique. Wood, glass beads, sinew, metal, feathers, animal hide; H. 14.1 cm (5½ in.). Collection of Laura and James J. Ross, New York. *This puppet once formed a pair with another one now in the collection of Kevin Conru in Brussels (see Klopper and Nel 2002: pl. 30a).*

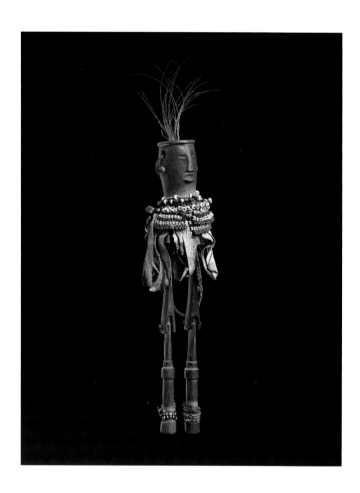

our regional focus. Some of the artists whose work is featured here were native to present-day Zimbabwe, Botswana, Swaziland, and Mozambique to the north and northeast of South Africa. The major Bantu-speaking peoples who inhabit this area, whose distribution is also indicated on the map, are divided into five major linguistic and cultural groups: Nguni, Sotho-Tswana, Tshwa-Ronga, Venda, and Shona (Vogel and Nettleton 1985: 52; Valentin 2002: 30–32; Gowlett 2003: 609–10). The Nguni are further subdivided into northern and southern groups. Strictly speaking, the Xhosa belong to the Southern Nguni, along with the Tembu, the Mfengu, and the Bhaca among others, but the name "Xhosa" is often used to denote the totality of these populations living in southern KwaZulu Natal. The Northern Nguni encompass the different Swazi, Ndebele, and Zulu groups. The Sotho-Tswana extend from Lesotho to Botswana. Three groups are distinguished on a geographical basis: Southern Sotho, Western Sotho (Tswana), and Northern Sotho. The Tshwa-Ronga group includes the Tsonga, a name that refers to different communities that have gradually emigrated from southern Mozambique since the second quarter of the 19th century and are currently mostly located in the province of Mpumalanga. The Venda, culturally closely related southern neighbors of the Shona people of the Zimbabwe "highveld," inhabit northern South Africa and southeastern Zimbabwe.[5]

Most of the works depicted and discussed in the following pages were made and used by cattle herders in the 19th or 20th century. Their materials and size reflect the migrant culture of these peoples, while their symbolism and meaning reveal the centrality of belief in the ancestors and the value of cattle. However, the area south of the Zambezi is also home to some of the oldest expressions of human creativity in Africa. Unlike the portable objects illustrated here, the rock paintings and engravings discovered more than a century ago in the mountainous regions of the southern subcontinent have long been recognized as art, even though they were misunderstood until very recently. They were made by the predecessors of the modern San—sometimes still referred to by the derogatory "Bushmen"—and most likely functioned in a ritual context (see Lewis-Williams 1983 and 2002). The oldest known

paintings of this nature, charcoal drawings on rock slabs found in the so-called Apollo 11 Cave in southern Namibia, date back to 27,000 BC and are thus as old as the well-known rock art of Spain and France. Closer to our time, the most spectacular works of art from what archaeologists call the Early Iron Age are without doubt the seven terracotta heads from the site of Lydenburg in the eastern Transvaal, which have been dated between AD 500 and 700 (see Patricia Davison, in Phillips 1995: 194–95, cat. 3.10a-b; Van Schalkwyk 1996). Of course, mention should also be made of Great Zimbabwe, which from 1250 to about 1450 was the capital of a kingdom constituted by the forebears of the present-day Shona people (see Garlake 2002: 146–62). It is known for its monumental stone architecture, as well as for a variety of stone carvings. The decline of the Zimbabwe kingdom is believed to have stemmed from its loss of control of the Indian Ocean trade. By the early 16th century this trade was entirely in the hands of the Portuguese.

Most of the works illustrated in this volume were made and used when much of the region was under British rule. In fact, as mentioned earlier, many objects were taken to Europe as souvenirs, and sometimes as loot, following the Anglo-Zulu War of 1879 or the South African War of 1899–1901. British colonization beginning in the late 18th century had a much more lasting negative effect on the pastoral societies that had produced such personal and domestic objects since well before domination by foreign powers from the early 16th century onward. The imposed political regime changed the power relationship between rulers and their subjects, while missionaries eradicated local beliefs and practices. As a result, the material culture associated with these "traditional" contexts often changed profoundly and sometimes disappeared altogether.

Whether household or personal objects, the works related to these pastoral cultures are typically small and easy to handle and carry. As such, the rapport between object and owner is often very intimate. Resulting from many years of direct contact with the human body, objects show traces of wear and tear, their edges softened; they also acquired a shiny or even lustrous patina. It is perhaps this physical or even bodily nature—both in terms of scale and use—that distinguishes the arts of southeast Africa. Against this background it is also easy to understand the pre-eminence of beadwork in the artistic legacy of the region. Despite the low esteem it still holds among many African art amateurs—probably due in part because it is a product of cross-cultural contact (the earliest glass beads were imported from Europe) and the work of women—beadwork is of central importance to the peoples of southern Africa. Ironically, much of this beadwork is actually textural and sculptural in form, and, when viewed in conjunction with a human body in movement, the aesthetic effects of beadwork are usually kinetic (Van Wyk 1994: 64).

Regretfully, space constraints did not allow including more examples of the many different regional beadwork traditions in this exhibition and its catalogue. However, because the selection was limited to those object types that fit within our broad category of applied or decorative art, the freestanding figure sculptures used by the Tsonga and Venda in initiation rituals were consciously excluded. Still, other object types are much more difficult to classify, and their retention or rejection was therefore sometimes arbitrary. In this respect, perhaps the marvelous Tsonga puppet with movable limbs from the collection of Laura and James J. Ross—which was possibly used in a divination context (fig. 3)—should have been included.

African art collections in the West are by definition limited and subjective because they contain only what has been preserved and acquired. With regard to the arts of southern Africa, which have been underrated and misunderstood until very recently, what we have is obviously not more than a fragment of what has been created and used. In this sense any exhibition on this subject matter is selective and biased as a result of both the personal preferences and choices of the curator and the absence of certain materials in collections. *The Art of Daily Life* does not have the ambition to offer an encyclopedic survey of the arts of the southeastern part of the African continent. The focus on portable objects related to the household and the person, and the limitation to borrow only from American collections, are among the principal reasons why this exhibition and its companion publication cannot be but fragmentary and incomplete. We hope nonetheless that they succeed in contributing a change of attitude and perhaps even of taste in the evaluation and appreciation of southern Africa's rich artistic heritage.

1. Compared to the London original, the New York version of the exhibition presented at the Guggenheim Museum in 1996 was not only significantly smaller, many of the London loans had been substituted (compare Phillips 1995 and *Africa* 1996). Roy Sieber's 1980 exhibition for the American Federation of Arts is considered the first major event in the United States in which furniture and household objects from southern Africa were placed on the same footing as works from other parts of the continent (Sieber 1980). In 1979, the Smithsonian Institution's National Museum of African Art organized a modest exhibition featuring 43 works of Ndebele beadwork from the Chaim Gross Collection (see Priebatsch 1980). In 1982, an exhibition on Zulu arts was held at the Stewart Center Gallery, Purdue University, under the title *The Geometric Vision* (Conner and Pelrine 1983). However, in 1983–84, the Canton Art Institute in Canton, Ohio, presented what I believe was the first survey exhibition on art of southern Africa, *African Elegance: The Traditional Art of Southern Africa*. It was curated by Rhoda Levinsohn, an expert on the art of the region who at the time lived in Cleveland. Not only did she write the accompanying brochure, she was also the source of the more than 500 loans (Levinsohn 1983; see also Albacete 1984 and Levinsohn 1979 and 1984).

2. See Dewey and De Palmenaer (1997) for the Tervuren exhibition, Eisenhofer (2001) for the one in Linz, and Joubert and Valentin (2002) for the one in Paris. Both the Paris and Linz exhibitions were encyclopedic in their approach and the latter also addressed issues other than art and material culture. The exhibition *Austausch* (Exchange) that the Vienna Museum für Völkerkunde organized in 1998 also included an important selection of its rich holdings of southern African art (Plankensteiner 1998). Before these European projects, South African institutions had organized a number of important more specialized exhibitions that built on the foundations laid by *Art and Ambiguity* (see Levy 1992; Bedford 1993; Wood 1996; Dell 1998). In 2004–5, a selection of 32 works from the Johannesburg

Art Gallery was shown at the Museum for African Art in New York (Nel and Gwintsa 2004). Most recently, the Johannesburg Art Gallery presented an exhibition on Tsonga and Shangaan art (Leibhammer 2007).

3. The bulk of the National Museum of African Art's collection of material from southern Africa was acquired in 1989 from Dr. Werner Muensterberger in New York and Michael Graham-Stewart in London. The influence of Roy Sieber's work in the establishment of this collection cannot be overestimated (see also Klopper 2004: 20–21). One of the notable nonart museums that deserves to be cited in the context of American public collections is the Field Museum in Chicago, whose holdings of southern African beadwork in particular are arguably among the richest in the Western world (see Stokes 1999).

4. The name "Kafir" or "Kaffir" (also spelled "Kaffer" or "Cafre" in Dutch, German, and French sources), which is commonly used in the literature from the 18th century onward and also associated with the oldest European museum collections of southern African material, would be derived from the Arabic word for "nonbeliever" or "infidel." Although it is usually translated as "Zulu," the term actually refers to all Bantu-speaking peoples of the region, while many of the so-called Kafir works in early collections are in fact the work of Tsonga artists and craftsmen.

5. Aside from the various sources listed in the Works Cited, the entries on specific peoples of southern Africa in *The Dictionary of Art* (Turner 1996) are very useful introductions to the artistic traditions in question; see William Dewey on the Shona (28: 620–22); Sandra Klopper on the Zulu (33: 724–25); Anitra Nettleton on the Venda (32: 154–55); and Elizabeth Ann Schneider on the Ndebele (22: 712–13). Though perhaps somewhat out of date, the books by Barbara Tyrrell (1968) and Alice Mertens and Joan Broster (1973) have retained their merit as general surveys of the demography of the region.

MIGRATORY AESTHETICS:
THE ART OF THE CATTLE CULTURES
OF SOUTHERN AFRICA

Karel Nel

The exhibition *The Art of Daily Life: Portable Objects from Southeast Africa* affords a rare opportunity for the New World to see historic pieces from southern Africa selected from American private and public collections. Displaying such objects so separated from their original context and society presents a challenge to viewers and curators alike: divorced from the cultural matrix that conceived, made, and valued them, these utilitarian items are easily viewed without an imaginative grasp of their inherent significance. A Western analogy would be considering a chalice simply as a wine glass. Without access to its symbolic and ritual associations, a chalice might readily be misread by someone from another culture as an ornamented drinking vessel. Christian values are so much a part of Western culture that one takes in, without additional explanation, the symbolic nature of the vessel in which the miracle of the transubstantiation takes place. Wine becomes the salvatory blood of Christ. The object acts as a mental catalyst, transforming the earthly into the numinous, but only for those within the cultural bounds.

So, the challenge for both curator and viewer is: "How do we imaginatively enter the thought world of the object itself. How do we get to see it imbued with all the meaning associated with its genesis." For almost every object that surrounds us in our homes and places of work is concretized thought, be it a light bulb, a chair, or an eraser. Conceptualized and brought into the world, these objects exemplify a complex syntax of ascribed values, be they conscious or unconscious. Our world of plastic, stainless steel, and glass is a world away from one that valued and made use of grass, clay, wood, horn, and beads. These are the materials of an environment of tree-studded grasslands, threaded by streams where clay could be sourced from the damp riverbeds. This was the world of the nomadic pastoralists who grazed their cattle along Africa's southeastern seaboard, a far cry from the grids and towers of American cities and the vast precision of the agricultural tracts inscribed on the Great Plains.

Is it possible to backtrack imaginatively along the flight path of these small objects from southern Africa as they in more recent years have made the trans-Atlantic crossing, tracing the changes in their significance and value? Bought from serious dealers in Europe and through major auction houses in cities such as New York, London, and Paris, these modest pieces have—in the act of migration—been transformed from their colonial curiosity status into important financial and artistic assets. This new appreciation of the minimal and understated aesthetic of objects from southern Africa is both a post-Cubist artistic and a post-apartheid sociopolitical re-evaluation.

Is it possible to backtrack further, this time on a slower South-North Atlantic crossing, from Port Natal in South Africa to Plymouth in England during the British colonial period? That voyage, for soldiers, administrators, and missionaries returning home, effected a profound change of values that transformed, for instance, an ancestral staff—unceremoniously cut down to size—into a mere walking stick. Take Zulu headrests, for instance. Inherently portable, many were brought back as souvenirs or oddities, perhaps especially because they did not correlate in any immediate or recognizable way to objects in the society to which the travelers returned. Disconnected from their cultural and symbolic sources, these pieces existed in a kind of limbo, awkward anomalies in European parlors until finally relegated to the campaign chest or attic. Many returned to circulation only generations later through small town auctions and the famous Portobello Road flea market in London.

FIG. **4.** Snuff container. Zulu people, South Africa, or Southern Sotho people, Lesotho. Horn, wood; H. 26.6 cm (10½ in.). Private collection.

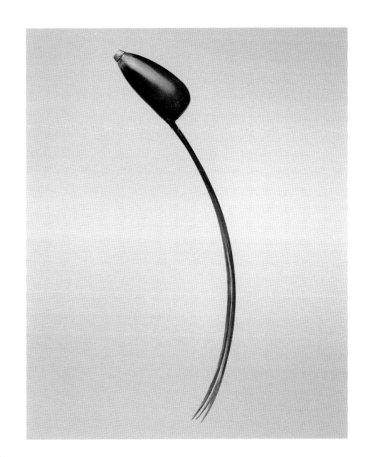

Back in southern Africa, the impact of the colonial invasions quickly and decisively nullified the integrity of the traditional value systems that had nurtured the making of these significant objects. Long-tined horn snuff containers that could be elegantly inserted as hair ornaments (fig. 4) gave way to commercial snuff tins that slipped inconspicuously into the pockets of trousers adopted from the West. Robust enamel bowls replaced refined but fragile clay vessels (cats. 40, 41) and wooden meat platters (fig. 5). The use of traditional headrests waned as Western-style beds and bedding came to represent acquiescence to a new order. The beds, in turn, changed the parameters of the internal space of domestic dwellings, altering the mental gestalt of hemispherical grass domes (fig. 6) into that of Western rectangular spaces.

Is it possible, once again, to go back even further in order to relocate these pieces in something like their place of origin? Can we imaginatively recontextualize them so as to really begin to see and understand them? Returning to the Zulu headrest as a single significant marker within the culture, we might begin to understand how these objects are imbued with social and spiritual meaning that informs various symbolic transactions. A headrest is a simple but subtle wooden support for the neck, carved from a rectangular block of wood. Headrests often have a severe, architectonic quality with a monumentality surprising in objects so small. These bold geometric forms are frequently embellished with low-relief striations or cross-hatchings, or punctuated by small, telling detail. These beautiful, refined objects often have a deep glossiness that comes from years of use.

Marking a change of status for both young men and young women, headrests were presented as gifts from the bride's family at entry into marriage; headrests were a necessity because the change of marital status was marked by the adoption of elaborate coiffures (fig. 7). Headrests were ceremonially carried alongside the bride as she moved to her husband's family homestead. This transfer symbolically bound one family to the other in much the same way as the *lobola* (payment in cattle or cash) given to the bride's family did, and still does. In the Nguni cultures, both cattle and headrests were powerfully associated with revered ancestors, and both exchanges celebrated the combined wealth and fertility linking the past and the future of the families involved. Headrest and owner became deeply

FIG. 5. Meat platter. Zulu people,
South Africa. Wood; W. 80 cm (31½ in.).
Collection of Su and Jan Calmeyn,
Sint-Niklaas, Belgium.

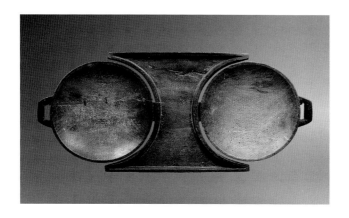

associated with one another; at death a headrest was often buried alongside its owner, and thus returned to the ancestral realm, or kept and revered as a link with the ancestor, who could be accessed in the dream state. These highly abstract objects were accorded similar status and respect as the ancestor figures of Central and West Africa. Headrests were sometimes ceremonially "dressed" with wildebeest hair and beads to honor the ancestors and empower the object (cats. 2, 3).

The centrality of cattle to the economic, cultural, and spiritual well-being of southern and eastern herders was physically manifested in the pattern of their settlements, which were concentrically arranged around the community's cattle kraal (fig. 8). Not only an enclosure where cattle were kept at night, the kraal was the place of political decision making as well as the site for the ritual slaughter of cattle and the burial place for important elders. In a sense, the kraal would be the equivalent of uniting the significance of Wall Street, the White House, Arlington National Cemetery, and Washington National Cathedral in a single locus. The quality of the relationship between the herder and his cattle is reflected in the languages of southern Africa. While noted for their general paucity of adjectives, these languages nonetheless have dozens of words for hide patterns and coloring, and many more for the relationship of the horns to the head and to one another. These descriptive words suggest the intense, observed quality of the relationship between herder and cattle. The cattle, circulated through their function as lobola, thus knit the social fabric together. A sister's bridal cattle might be used to pay for her brother's bride in a web that is simultaneously symbolic, social, and economic. An understanding of the web of associations that converge in an object such as a headrest was entirely absent when such pieces were removed from their context. Stripped of the significance with which they resonated, these objects became mute, no more than their functional selves.

Educational analyst Catherine Odora Hoppers (2004: 22) observes: "One of the consequences of colonialism for indigenous knowledge systems was the fundamental cognitive triage and erasure that was imposed on the rich knowledge heritages of non-Western people. By declaring non-Western lands to be 'empty' (that is, devoid of people or ideas), and the diverse sciences and innovations that steered and maintained those societies as 'non-science', the cultural and intellectual contributions of non-Western knowledge systems were systematically erased." Within these preliterate cultures, knowledge was maintained and passed from generation to generation orally. Devaluing this knowledge and rupturing its transmission—often in the face of Western schooling—led to its disintegration and disappearance.

Only in the past fifty years has a miscellany of objects, collected in southern Africa during the colonial hegemony and disseminated primarily through Britain, France, and Switzerland, started to be reassembled into coherent groups.

FIG. **6.** The typical dome-shaped Zulu dwelling. KwaZulu Natal, South Africa, probably early 20th century. Photographer unidentified. Postcard published by the Newman Art Publishing Co., Cape Town.

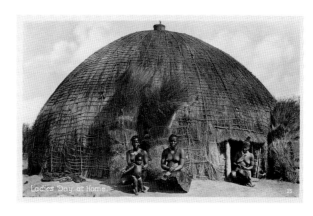

Many pieces were collected during the British-Zulu wars by soldiers, visiting colonialists, and missionaries, and this practice continued well into the early part of the 20th century. Almost no records exist concerning where these objects originated, who made them, and their significance beyond their immediate functionality. Certain museum collections came into being as a result of objects ceded to them by families to whom they had no more than a passing significance. The British Museum's collection of early southern African cattle culture objects is a case in point. The same is true of museum collections in other British cities such as Birmingham and Sheffield, both of which sent regiments that fought in the British-Zulu wars and returned with weapons and other objects.

In the 1960s, collectors such as Jonathan and Eve Lowen in England and Udo and Wally Horstmann in Switzerland began collecting pieces from southern Africa in a deliberate and focused manner. These collectors identified a general southern African aesthetic and chose to acquire accordingly, without always knowing at the time the specific provenance of the pieces. With like objects clustered together, the recognition of different cultural identities within a broader southern African aesthetic began. These two European-based collections have returned to museums in southern Africa, where they have generated intense scholarship that strives to reconstruct the context, nature, and meaning of the objects from the fragmentary information associated with them and from analysis of the relationships among the objects themselves.

With the improved understanding prompted by these collections, identifying a complex series of cultural affiliations extending northward along the East African seaboard has finally become possible. From scattered and incomplete evidence, alliances and migratory patterns are tentatively being mapped. A more sophisticated understanding of this history has helped establish cultural traces within the pattern of the visual vocabulary of objects from southeastern Africa. While a general understanding of the broad trends within these patterns now exists, vexing anomalies highlight how little we know. Evidence of the continuity of aesthetic patterns of preferences in peoples physically distant from one another may signify that a migratory history connects these groups—a case in point is the similarity between the headrests of the Swazi of Swaziland and those of the Ngoni of Malawi and adjacent Tanzania, where the northerly migration is a known event (compare fig. 9 and cat. 7).

The absence of a meaningful context for the headrests mentioned earlier has resulted in a deep lack of understanding of the nature of these objects. Deprived of cultural context, a snuff container or a ceremonial staff viewed from the position of a dominant culture seems to be no more than a utilitarian artifact. Once relocated in the imaginative world in which they were produced, such objects reveal the contours of the society that shaped them. Thus, among the peoples of southeastern Africa survival involved cattle, resulting in an intensely symbiotic relationship.

FIG. 7. A young Zulu woman wearing
the typical peaked hairstyle and various
beaded adornments. KwaZulu Natal,
South Africa, possibly late 19th century.
Photographer unidentified. Collection
of Dori and Daniel Rootenberg, New York.

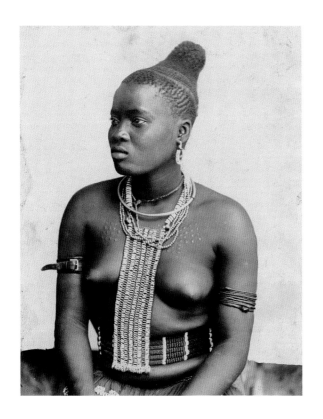

Caring for cattle determined the migratory nature of the group's existence, resulting in the construction of a set of beliefs coherent with this way of life. So, for example, reverence of the ancestors aligns with a profound respect for cattle, creating a symbolic world that reinforces and underpins the relationship between the group and its cattle, ancestors, and the fertility required for future survival.

In the culture of southern Africa, cattle are regarded as central to the male domain; in Europe, milking was the work of milkmaids and thus in the domain of women. Yet cultivation, where practiced in southern Africa, was and is regarded as the responsibility of women; in Europe, men were mainly responsible for growing crops. The marked division of activity into male and female domains in southern and eastern Africa can perhaps best be understood by the significance of milk, the life-giving substance that served to bind the male and female realms on a daily basis as well as in ceremony. Historian Noël Mostert (1992: 771) argues that "women were rigorously excluded from the process of milking and drawing and apportioning milk. For a woman to take milk from a milk sack in which fresh milk lay fermenting could be grounds for repudiation and divorce. . . . Yet it was a bride's acceptance of the milk of her husband's family and the joyful cry 'She drinks the milk!' that provided the final tie of the marriage." The author also writes: "Milk was to become the principal food of eastern and southern Africa's most noble warriors and nation builders. It became the basis of their daily rituals. The cattle herd . . . became in southern Africa the supreme symbol of social harmony, wealth, pride and power before the same masterful theme arose in different circumstances with the *estancias* and ranches of the Americas. The black cattlemen of Bantu-speaking Africa were élitist, masters of a particular concept of universe and self, with a 'royal, aristocratic, religious and emotional attachment' to cattle that involved their entire sense of social structure and law, and which in southern Africa reached its fullest expression" (Mostert 1992: 70).

As with the division of labor between farming and herding, there exist similar strict gender divisions regarding the manufacture of the symbolically laden objects made for daily use. Men carved and used elongated wooden pails, gripping them between their thighs during milking. The Zulu milk pail exemplifies the typical tall, narrow tapered form that these vessels took (cat. 42). The upper external surfaces often have carved decorative lugs and raised designs that prevent the pail from slipping. These features often allude to female breasts and scarification, which is

FIG. 8. Kraal. KwaZulu Natal, South Africa, mid 19th century. Print after a sketch by Mr. E. Redinger, from Shooter 1857, 12.

21

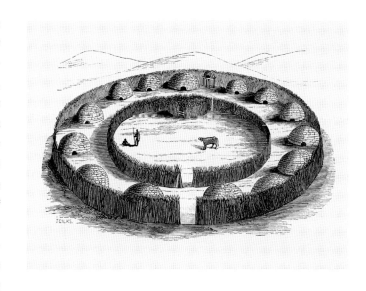

associated with both humans and animals. Men then poured the life-giving milk into the fired-clay vessels, which were made by women, transferring it from the male to the female domain. Clay, unlike wood, was one of the materials primarily used by women. Cured hides, beads, and gourds were other materials that women rightfully used, while metal, raw hides, bone, horn, and wood were processed and used by men. The ample swellings of the two typical examples of Zulu ceramics in the exhibition are also embellished, one with X-shaped swathes of clay pellets that had been moistened and pushed onto the surface before firing, and the other with low-relief rectangular grids that tip and touch corner to corner (cats. 40, 41). Sometimes these clay vessels are adorned with stylized breasts. These details reinforce the nurturing associations, since the womb-like interior held nourishment for the family.

The spoons used with the pots, however, sometimes have either male or female features. A spoon with a long cylindrical shaft may terminate in a geometric form reminiscent of the head of a penis (cat. 36). Alternatively, the handle could be embellished with two small breasts. The use of male and female motifs as adornment, while not ubiquitous, is certainly commonplace but does not serve as a marker for gender-related use of the object. In one unusual example the shaft of the spoon is surmounted by a complete female figure (cat. 31). Other spoons are miniatures, carved of bone or ivory, used for taking snuff. Frequently exuberant or outlandish in form, such spoons were regularly devised as hairpieces and jewelry as well (fig. 10 and cats. 32–35). They were often incised with small decorations into which black pigment was rubbed. The use of snuff and tobacco seemed to have both a social and a spiritual dimension, but also formed the basis for barter with European settlers.

The Xhosa pipes from the Eastern Cape province of South Africa derive from European prototypes, transformed into objects with an elongated, elegant bowl and lengthy, refined stem. These pipes, burnished from use, are at times decorated with wirework and beads, and at times embellished with inlaid lead detail (cats. 10–13). In other examples, the bowl takes on human or animal form, as in the case of the pipe from the Smithsonian Institution's National Museum of African Art in Washington, D.C., where the bowl becomes a female torso (cat. 14). The rim terminates at the shoulders of the figure, and this pipe may have had a little neck and head as a cap. The bowl is detailed with a delicately rendered pubic crescent, a little belly button, arms that cup the torso, and a pair of breasts. The stem enters the figure at the small of the back at an angle. Like headrests, snuff containers, and staffs, pipes were significant personal objects. A person would generally have owned and used only one of each

FIG. 9. Headrest. Ngoni people, Malawi and Tanzania. Wood; H. 14.6 cm (5¾ in.). Collection of Drs. Noble and Jean Endicott, New York.

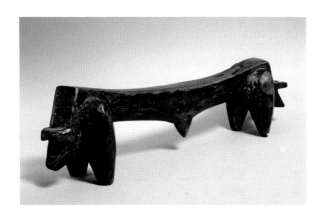

of these items in keeping with a spare, nomadic lifestyle; they would have been replaced only if some mishap occurred.

Pipes and snuff containers were not evidence of mere recreation because tobacco and snuff were associated with connecting to the ancestral realm. Tobacco was offered as a wedding gift, and smoking was thus indirectly associated with fertility and procreation, creating the link between the past through the present to the future. Snuff holders, frequently made of horn, ranged from small ampoule-like containers to those with long comb-like tines or flat spatulate forms or extravagant spiral extensions, all of which allowed the owner to wear the holder ostentatiously in the hair (fig. 4 and cat. 22). The constraints of the horn determined the shape of a snuff holder, making a virtue of natural curves, and the hollow interiors, plugged from below, provide dry storage for the snuff. The stored snuff was tapped out through a small stoppered hole in the upper part of the horn. In both the human- and antelope-shaped examples, the curve renders the figures alert and dynamic (cats. 23, 24).

Snuff holders were also made of tiny gourds, hollowed out, dried, and then polished and ornamented with beads or precise, geometric patterns created by stitching copper, brass, and iron wire through the rind of the gourd (cats. 15–17, 25, 26). The holder was closed with a plug at the point where the stem entered the gourd. These refined, subtle objects are reminiscent of the clay pots discussed earlier, but on a reduced scale. At the other extreme, the large ribbed wooden containers were also possibly used as high-status tobacco and snuff containers in a chiefly or court setting (cats. 28–30). The basic form of the vessel is simple, almost gourd-like, but in most instances looped handles run both horizontally and vertically around the form, terminating in an unexpected series of stabilizing feet. These containers are topped off with equally virtuoso lids, sometimes ending in an upward flare. Many of the vessels are darkly burnished using pokerwork, which scorches and seals the surface. It also seems likely that such pieces were collected or commissioned for important European exhibitions such as the Empire Exhibitions and World's Fairs, but their form surely had precedent with the vessels produced for special use.

Long ceremonial staffs and knobkerries (short clubs with a knob at one end) also found their way back to Europe, as both souvenirs and war booty. On occasion, the small, finely rendered human figures and animal forms that acted as finials were removed from the staffs and mounted on small bases, converting them into sculptures more in keeping with European taste. Two superb figures in the exhibition, both by the same carver, named the "Master of the Small Hands" by Sandra Klopper (2001), are characterized by a purity of form and an intensity of presence, despite their modest scale (cats. 56, 57). Klopper (1991: 90–93) also recognized the hand of another carver, whom she called the "Baboon Master" (cats. 54, 55). Knobkerries, or fighting sticks, were much shorter and stockier than staffs, which often signified the user's ceremonial or political status or, in the case of the sinuous snake staffs, his designation as

FIG. 10. A young Zulu man wearing several beaded necklaces and a snuff spoon through his pierced earlobe. KwaZulu Natal, South Africa, c. 1890. Photographer unidentified. Collection of Dori and Daniel Rootenberg, New York.

23

a healer (cat. 50). Knobkerries were generally used for hunting and fighting, but the refined, concentrically decorated Swazi examples were also signs of masculine prowess and identity (cat. 46). A gift from father to son at entry into manhood, the knobkerrie became deeply bound up with the receiver's personal identity, his connection with his peer group, his virility, and his link to the ancestral world.

Beadwork, associated with women, developed as a complex social signifier of gender, age, and marital status. The beads were used to fashion or decorate different forms of apparel: front aprons, back aprons, cummerbunds, vests, leggings, and collars, all of which would have been worn only by people belonging to a particular age group, gender, or status. Different colored beads, patterns, and color sequences evolved to reflect individual status and identity as well as more general group identities. As objects associated with and made by women, beadwork items were collected but have not, in the West, been given the same exposure or accorded the same status as the wooden objects associated with men. So, for instance, there are very few early examples in European collections

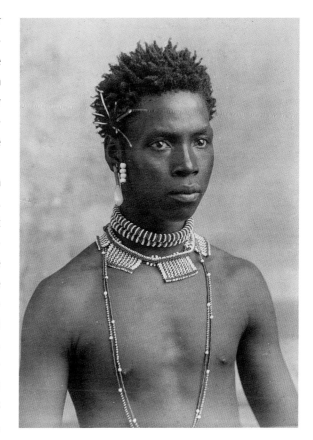

of the highly symbolic *isidwaba* (pleated leather skirt) (fig. 11). Such full skirts, made on the occasion of a woman's marriage, were crafted from the hide of the animal slaughtered ceremonially for the ancestors during the wedding. The earliest ornamentation on hide capes took the form of appliquéd chevrons or circles of contrasting fur or hide. This early form was superseded by bead ornamentation once small European glass beads began to be used for trade. From these small roundels of beads, the ornamentation was extended to include panels on the upper edge or down the center of the hide. In some instances the whole hide was covered with beads, as is the case with a small, early Xhosa (Southern Nguni) front apron with a swallow tail (cat. 72). Here, the ideogram-like patterns allude to the woman's sexual identity and her child-bearing potential. The elegant trailing white tails seem to allude simultaneously to the woman's legs and her labia. This, and the other beadwork pieces in the exhibition, gives only the smallest intimation of the rich variety of expression in this medium.

The combination of leaf green, dusty pink, and black and white beads organized in interlocking chevrons is characteristically Southern Sotho, although early Zulu beadwork shared this color sequence (cats. 68, 70). This sharing of color syntax suggests both physical and cultural proximity even while signaling distinct cultural identity.

FIG. 11. Married woman's skirt. Zulu people, South Africa. Cowhide; H. 59.7 cm (23½ in.). Wits Art Collection of African Art, University of the Witwatersrand, Johannesburg.

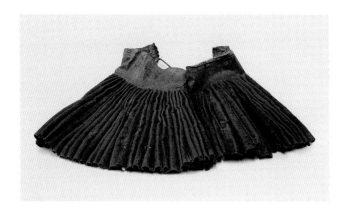

Interestingly, though, the little brown seeds at the ends of the fringe are particularly characteristic of Sotho beadwork. In addition, the slightly syncopated and eccentric geometry is also a Sotho characteristic; Zulu pieces tend toward more formal symmetry. In addition, the graphic checkerboard fringe in black and pink is to this day to be seen in the young Swazi girls' front aprons, a residue of this common heritage, at the Reed Dance held annually. The long Ndebele marriage veils, called *inyoka* (pl. *izinyoka*), were generally made of white beads threaded together to form a heavy, fabric-like band, now no longer supported by a leather backing. Early izinyoka were sometimes punctuated with small, refined geometric motifs in contrasting colors (cat. 66). Later izinyoka have much bolder, more colorful designs and fewer white beads.

The beadwork in a small Southern Sotho fertility figure reflects a fluid treatment of triangles that lean haphazardly into the surrounding white bands (cat. 78). The beading, done by women, covered conical wooden forms, carved by men. Embodying the co-operative skills of both men and women, these child figures were used symbolically to evoke an infant from the ancestral realm. They were given to nubile young women, perhaps as a token indicating they were regarded as ready for marriage and childbearing. Fertility figures among the Sotho and other southern African groups played a role in courtship, ensuring fertility and expressing to the ancestral realm the desire for a child. Historically, the Ndebele and Southern Sotho beaded-tassel pendant could be considered the origin of the conical child figure, with the tassel consolidated by a subsequent covering of a sheath of beads (compare fig. 12 and cat. 76). Receipt of these abstractly conceived little figures, which metaphorically embody the procreative act, had the same symbolic significance to a young woman as receiving a staff had for the young man: an acceptance of new status.

Only by creatively imagining nomadic life in a pastoral culture can we begin to understand that prized objects were not a massive bronze at a portal or a cumbersome oil painting to beautify a hall, but modest, symbolic, and useful objects that could be carried on the person. These objects celebrate the values of the culture in much the same way as "art" does in Western culture. Whereas in Western art materials were used in the pursuit of the mimetic, in the itinerant cultures of Africa the affective significance of materials determined their symbolic use: leather hide for a marriage apron; horn of a ritually slaughtered cow for a snuff container; gourds, grass, and reeds for fertility figures. The very constraints of the materials provide the impetus to find the most refined forms possible: the perfect, almost machined circularity of the bowl of a spoon; the delicately incised, ideogrammatic forms of Tsonga and Shona head-rests taking advantage of the close-grained, hard woods to hand; and the sweeping tine of the snuff container that reveres the curve of the horn from which it was made.

FIG. **12.** Fertility doll or "child figure."
Ndebele people, South Africa.
Glass beads, buttons, straw, cotton
thread, sinew; H. 23 cm (9 in.).
Collection of Udo and Wally Horstmann,
Zug, Switzerland.

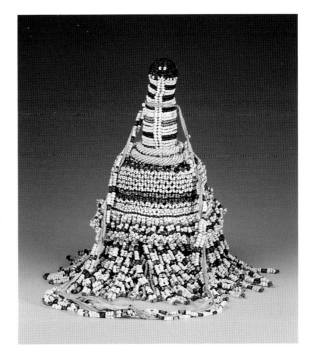

Thus, here, for "art" we should not be looking for substantial carved figures—although fine, rare, paired examples can be used in the *domba* (initiation ceremonies)—but recognize instead the extraordinary aesthetic power of milk pails, headrests, great ceremonial vessels, and small snuff containers. These objects, embedded in the very flow of life, were at their best made to exacting aesthetic standards. Western viewers have finally come to recognize and appreciate the beauty of these objects, primarily through the alteration of perceptions resulting from the strategic disruption of Western conventions by artists like Picasso and Brancusi. Their recognition of the potency of non-Western forms of representation initiated this transformation. Finally, it is possible to recognize that southern African art reflects the same quest for the perfection of form and function that we have come to know in the pure, machined aesthetic of the Bauhaus.

The change in status of these objects from curiosity to commodity to work of art has required an evolution of perception as aesthetic parameters have migrated through the radical shifts of art in the 20th century. The migration of these objects has not altered them in any way, but the manner in which they have been received has been radically altered.

With thanks to Elizabeth Burroughs for her invaluable contribution to both the content and the style of this text, and for her meticulous editing.

MAP

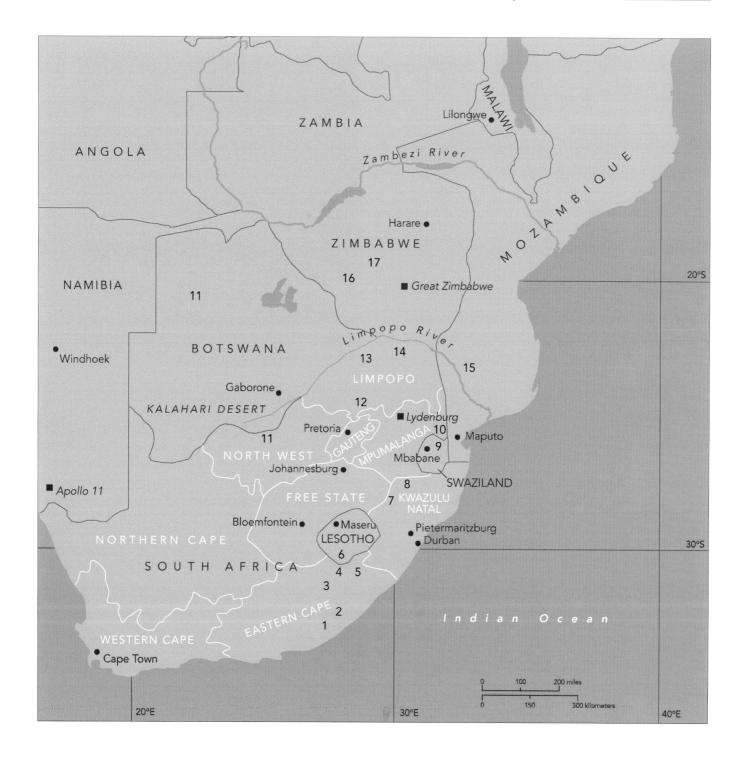

CATALOGUE

1 **Headrest** (two views)
Shona

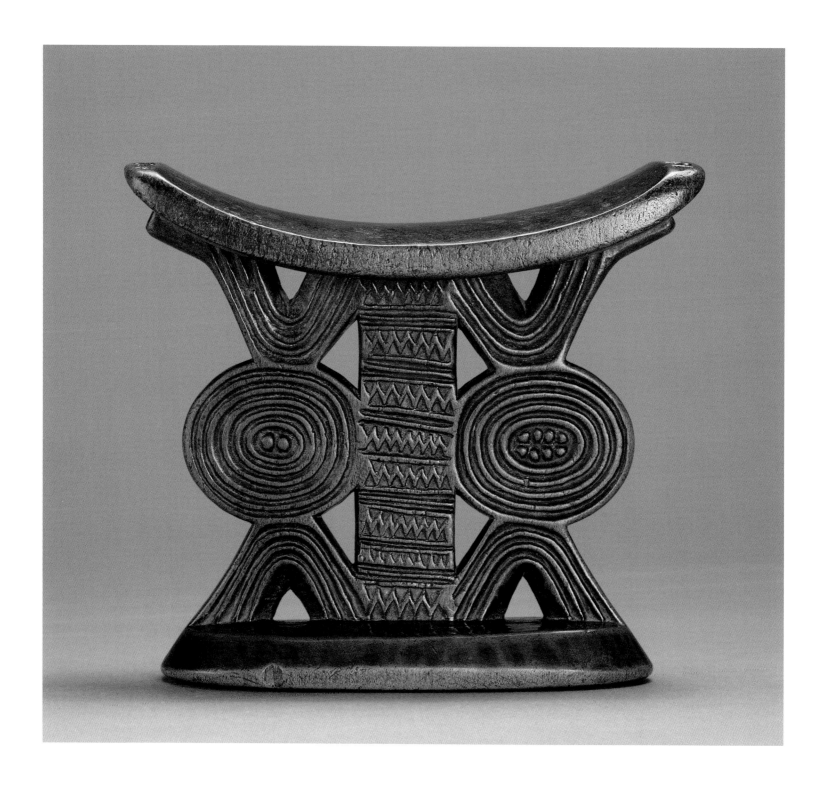

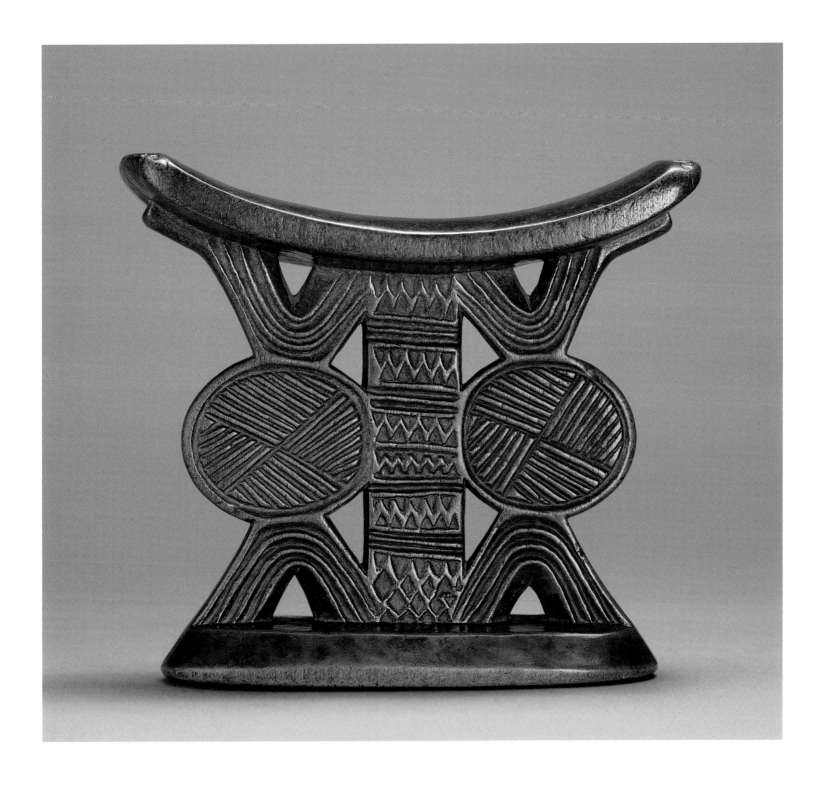

2 Antelope Headrest
Possibly Tsonga

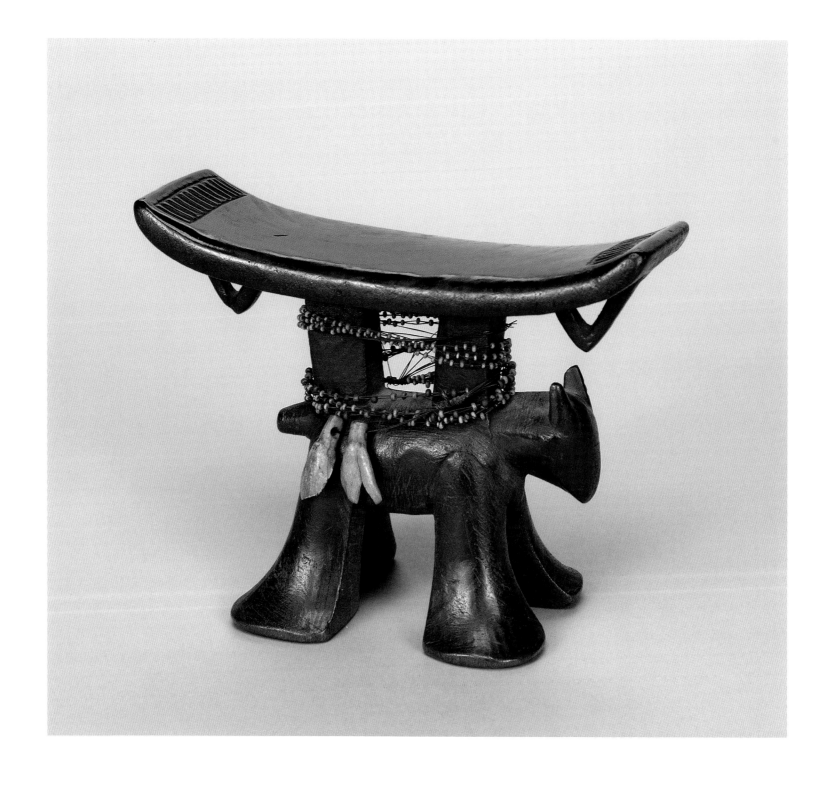

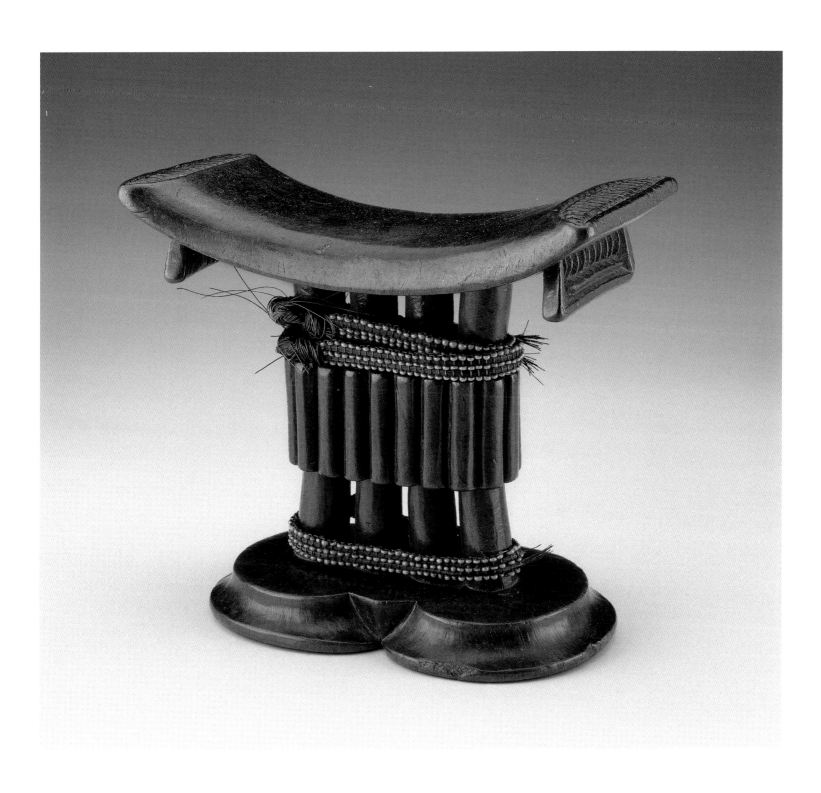

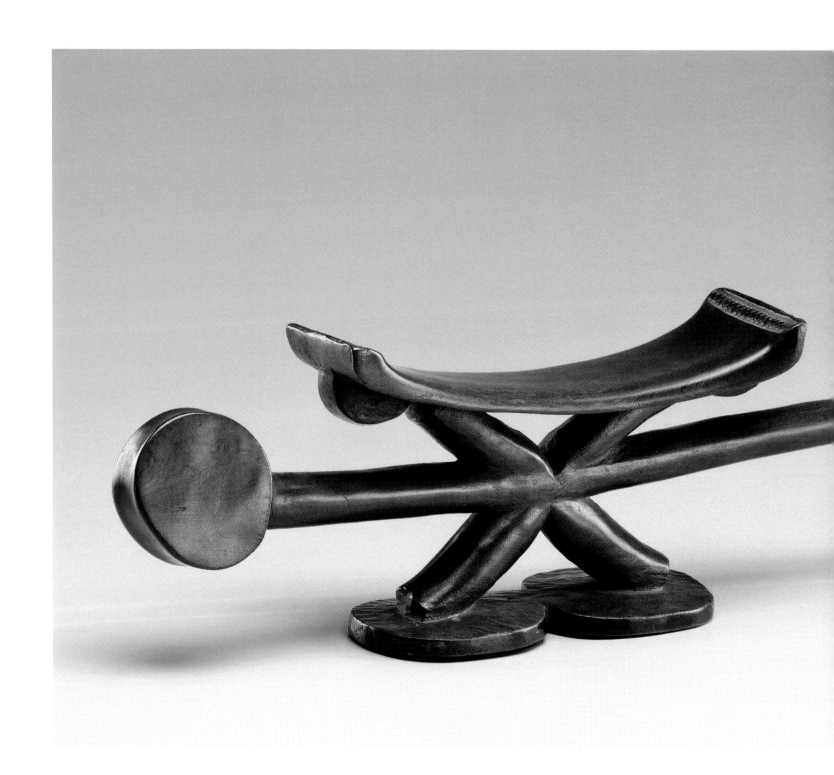

5 **Double Headrest
with Chain Links
and Snuff Containers**
Tsonga

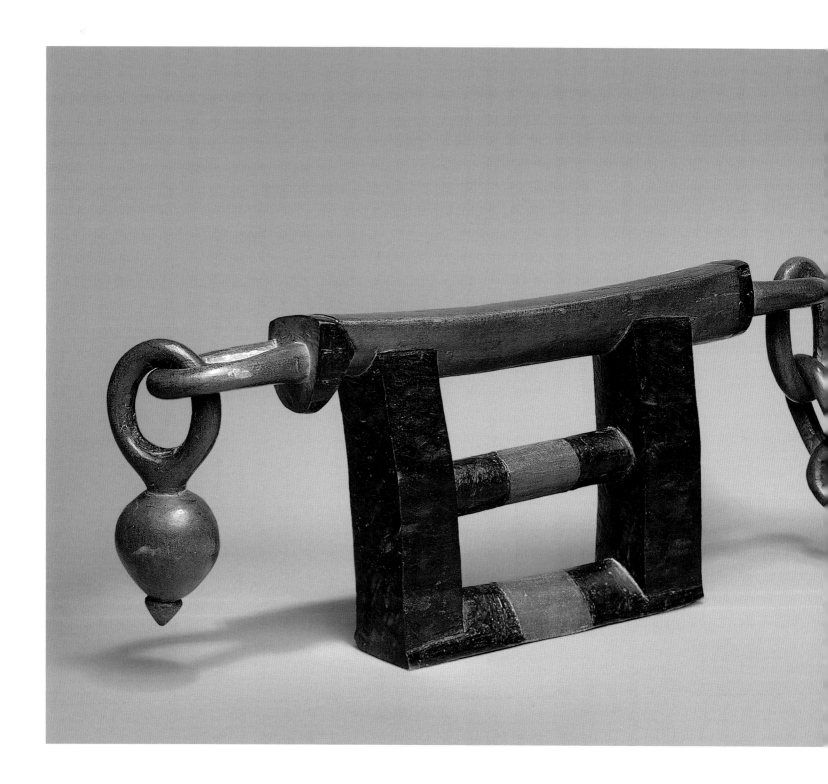

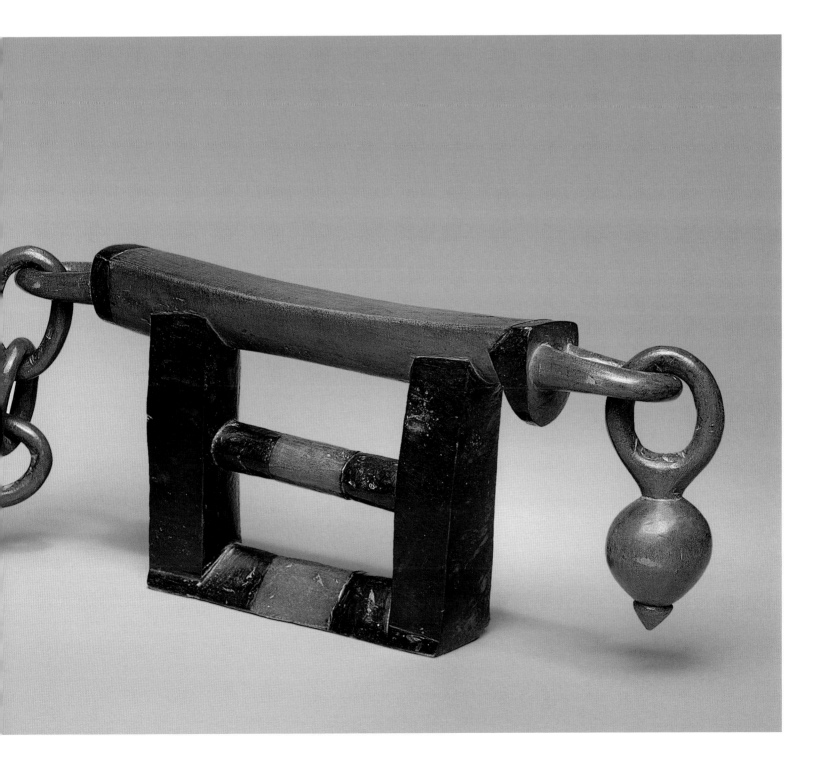

6, 7 Two Headrests
Zulu or Swazi | Swazi

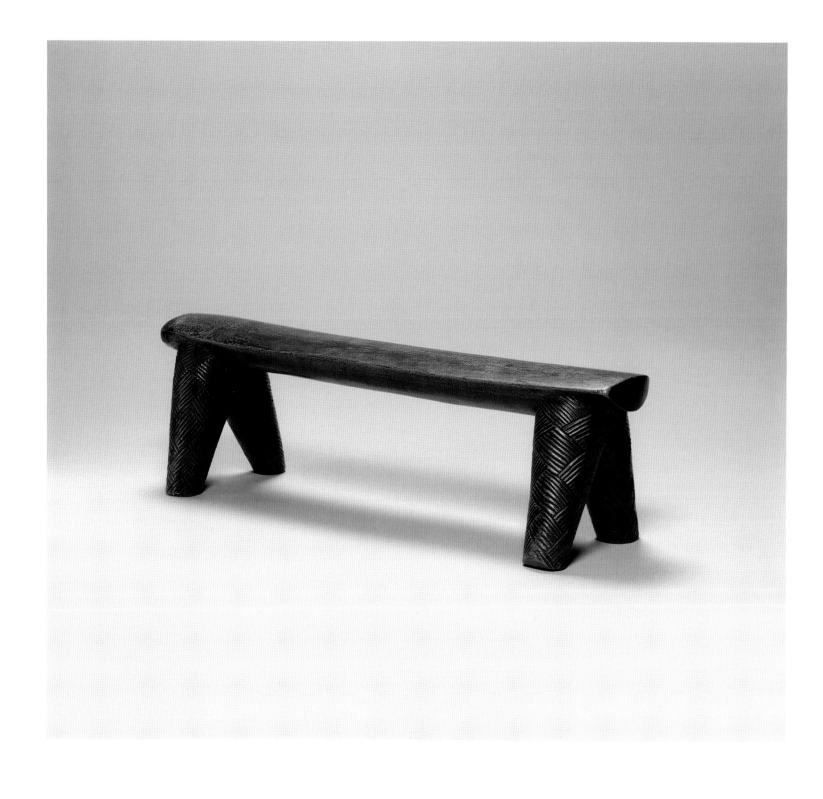

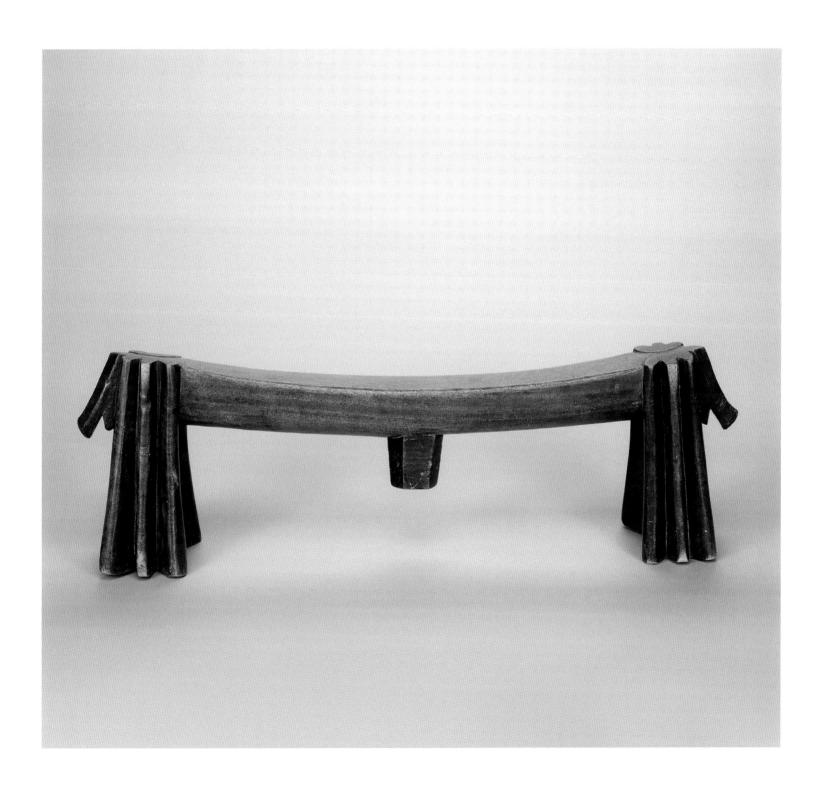

8,* 9 **Two Headrests**
Zulu

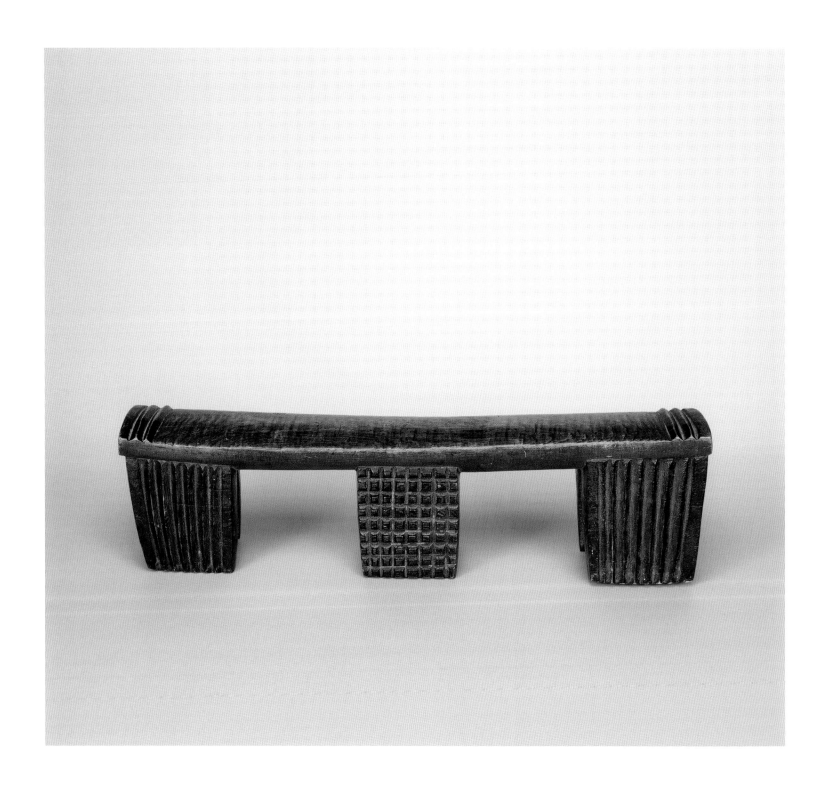

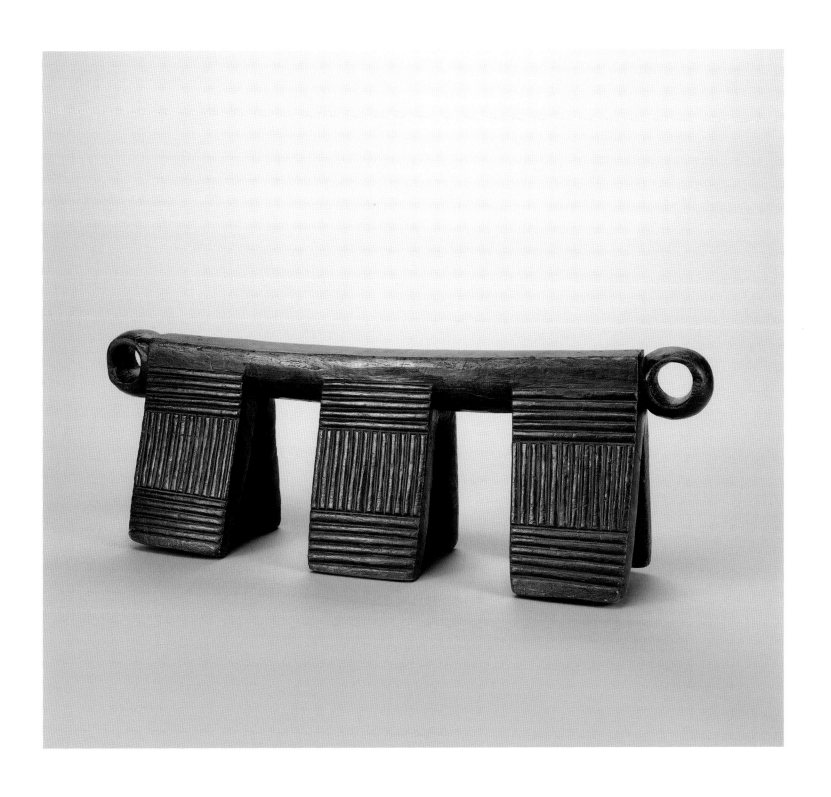

10 Pipe
Xhosa

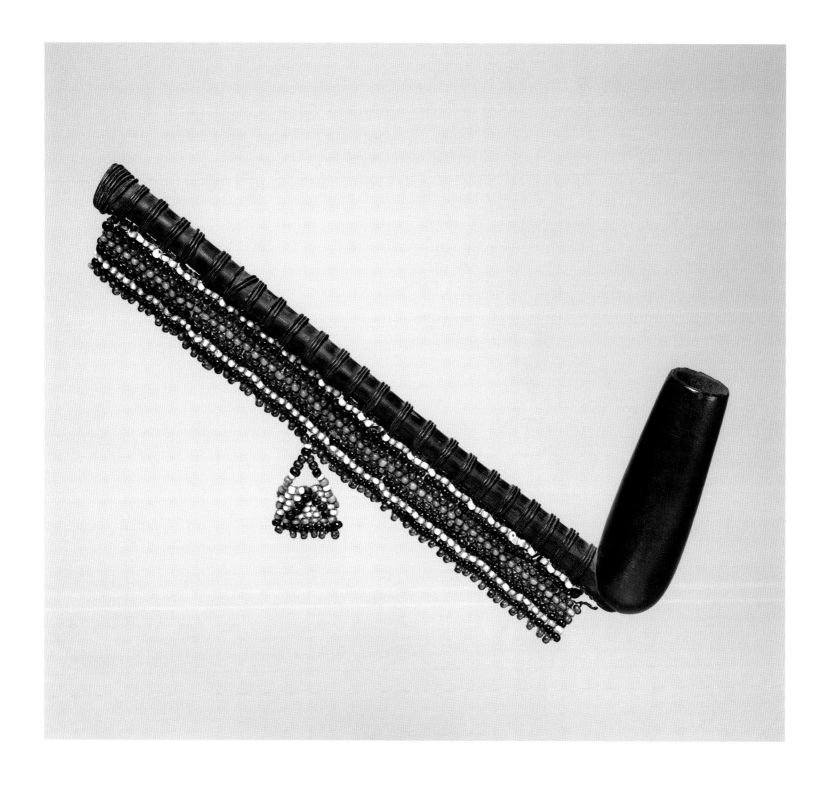

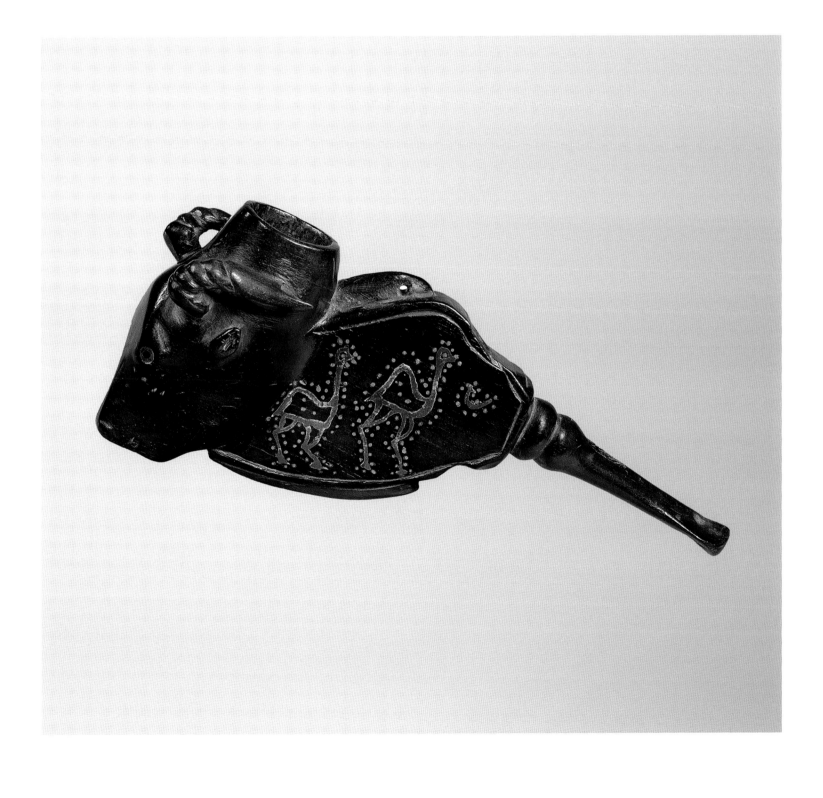

12, 13 Two Pipes
Xhosa

14 Pipe
Southern Nguni
or Southern Sotho

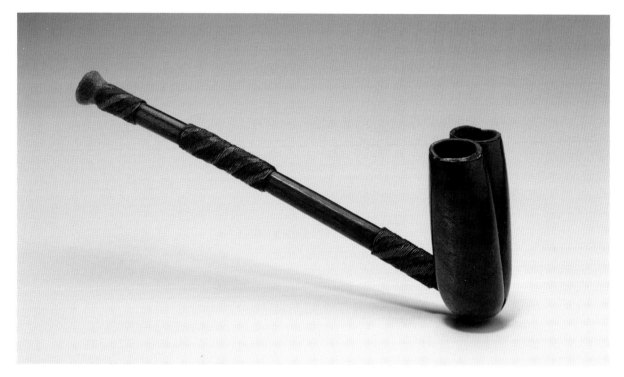

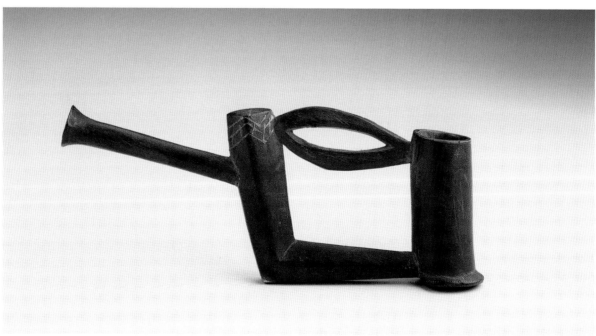

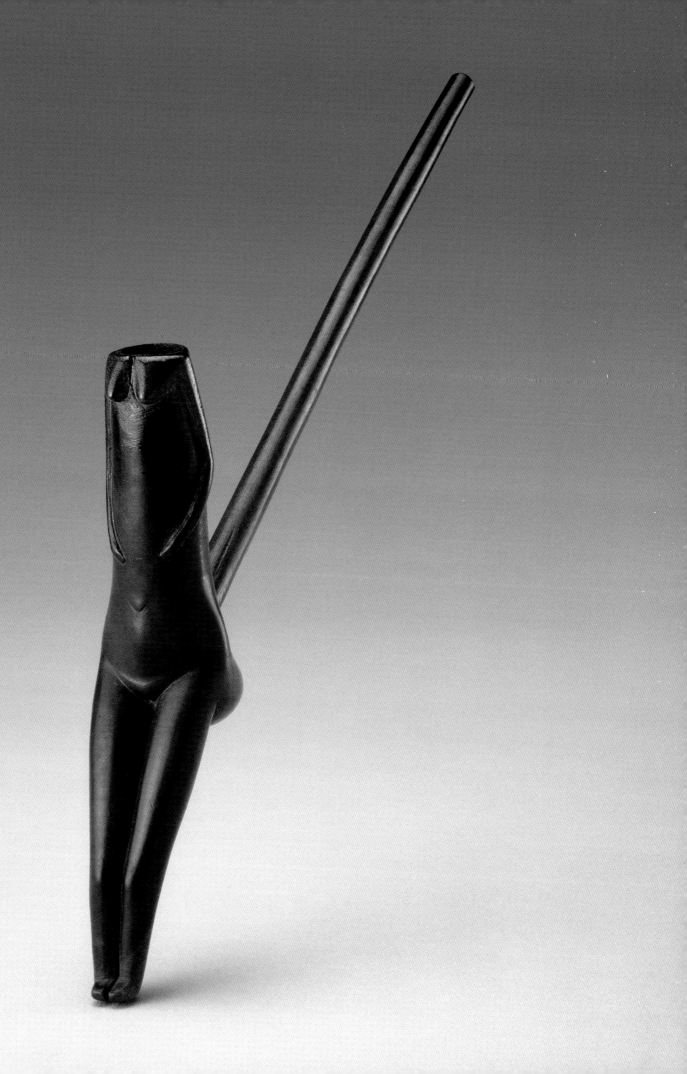

15, 16, 17 Three Snuff Containers
Undetermined ethnic origin

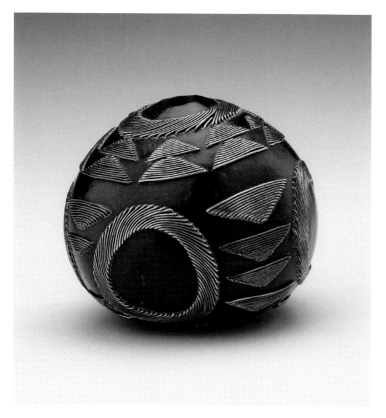

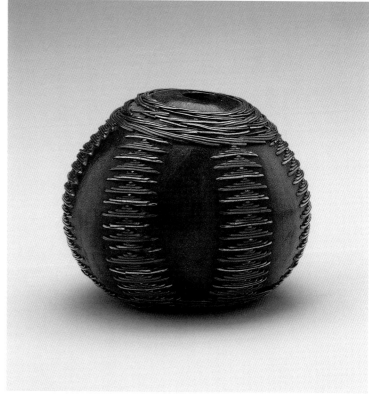

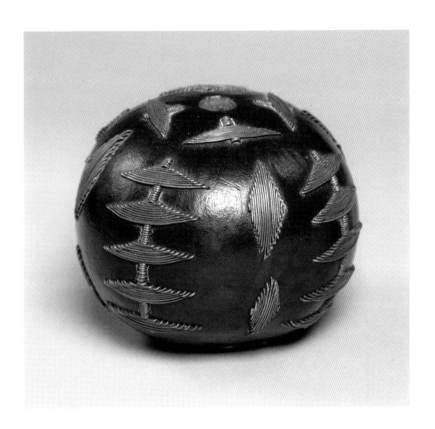

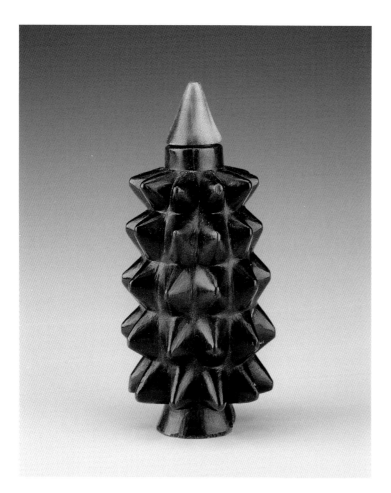

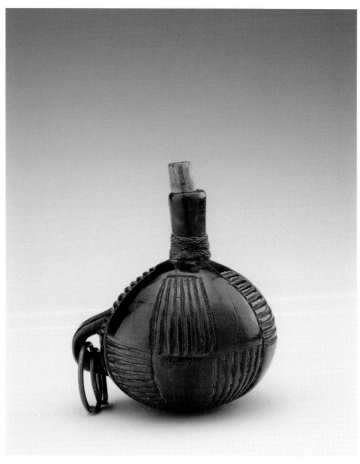

18, 19 **Two Snuff Containers**
Zulu | Shona

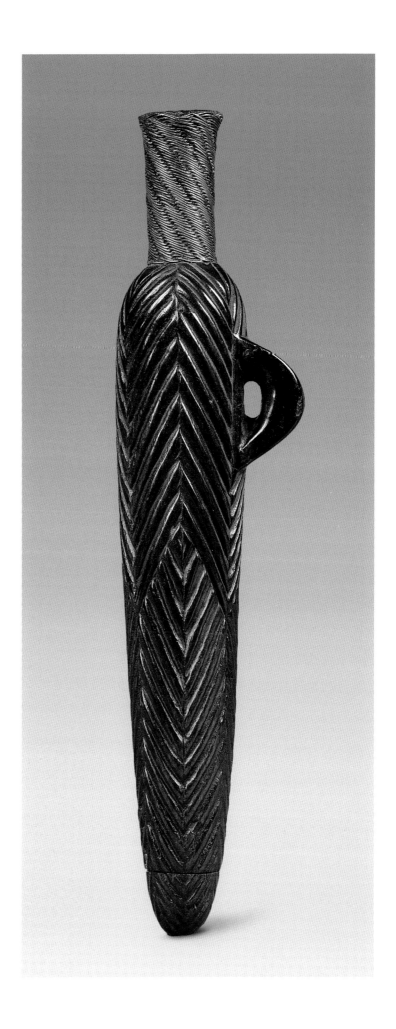

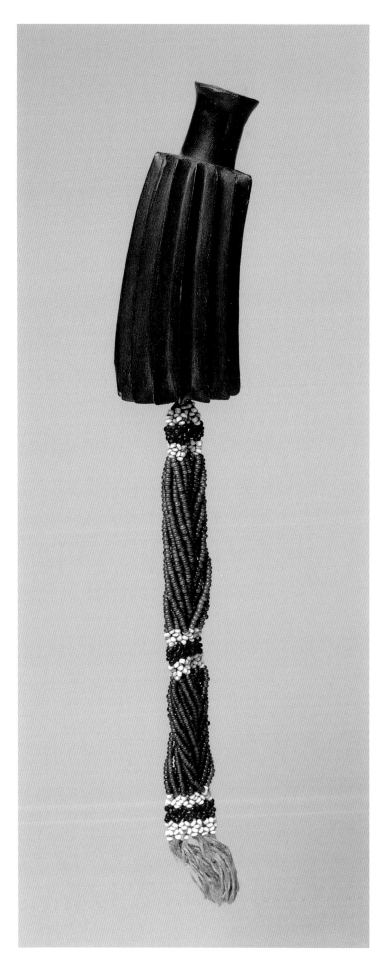

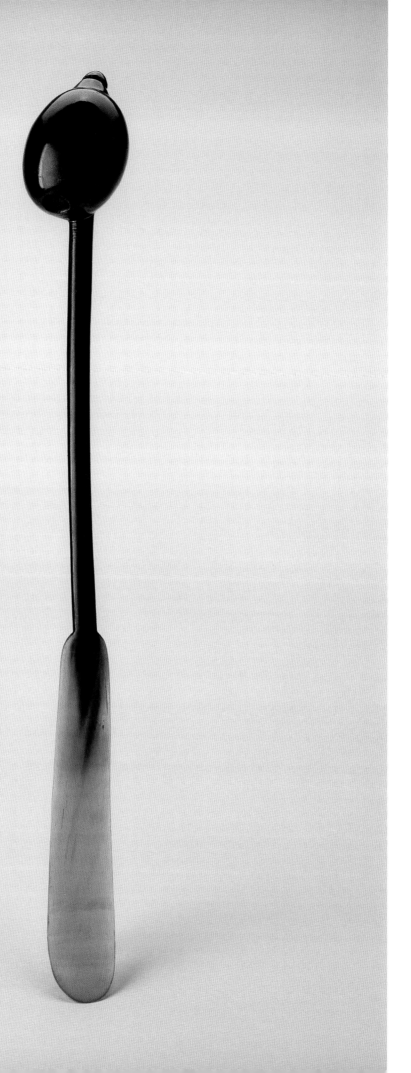

23, 24* Two Snuff Containers
Southern Sotho

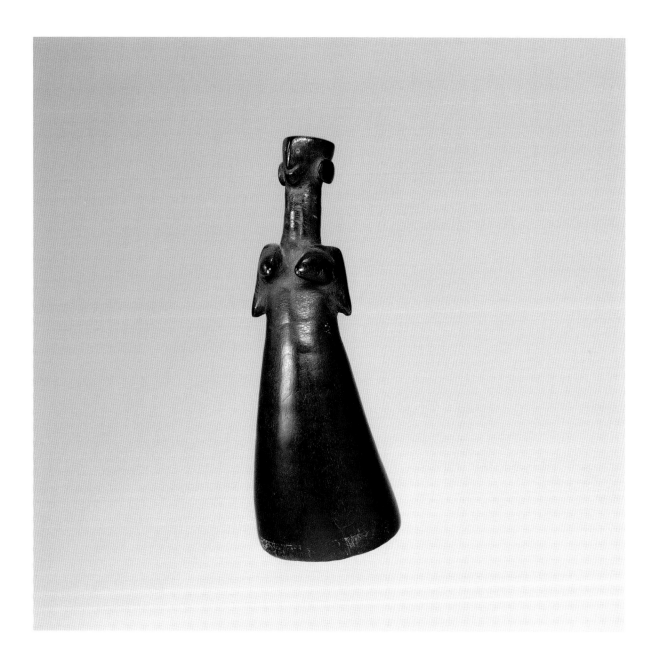

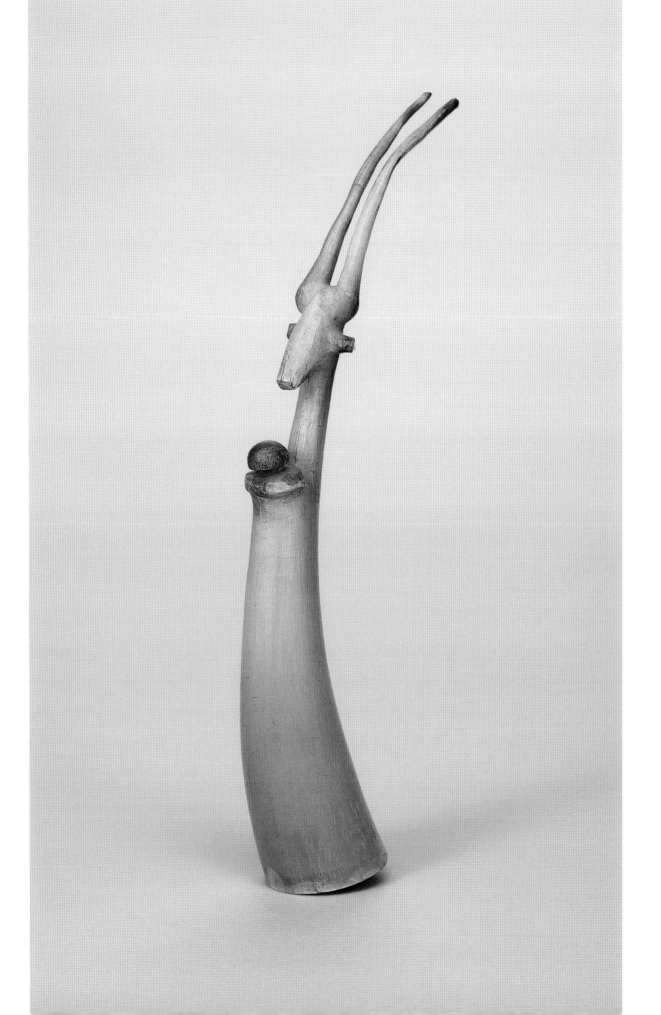

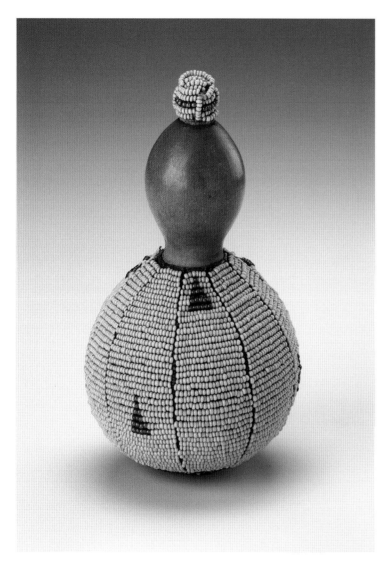

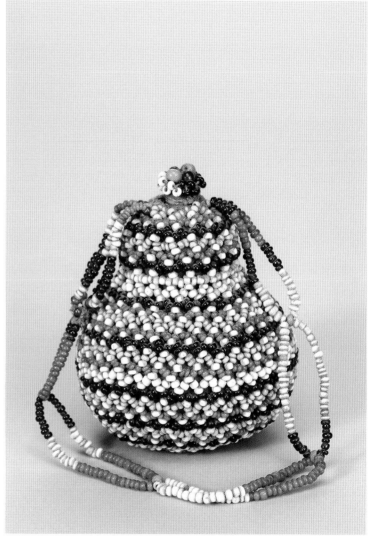

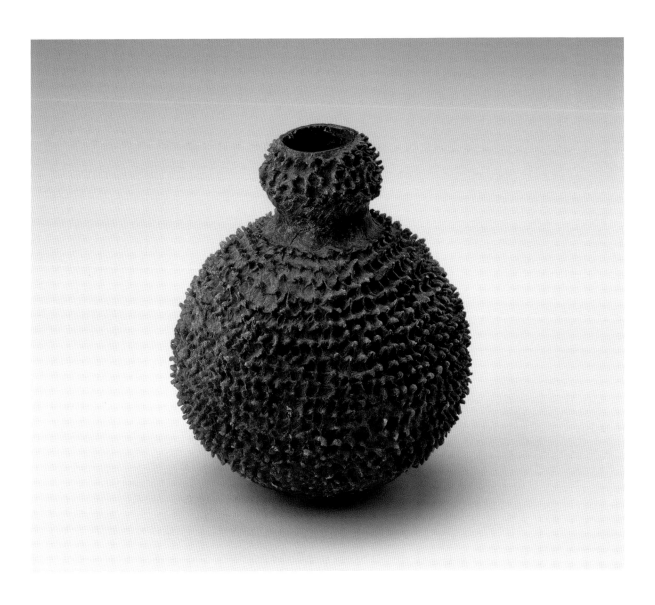

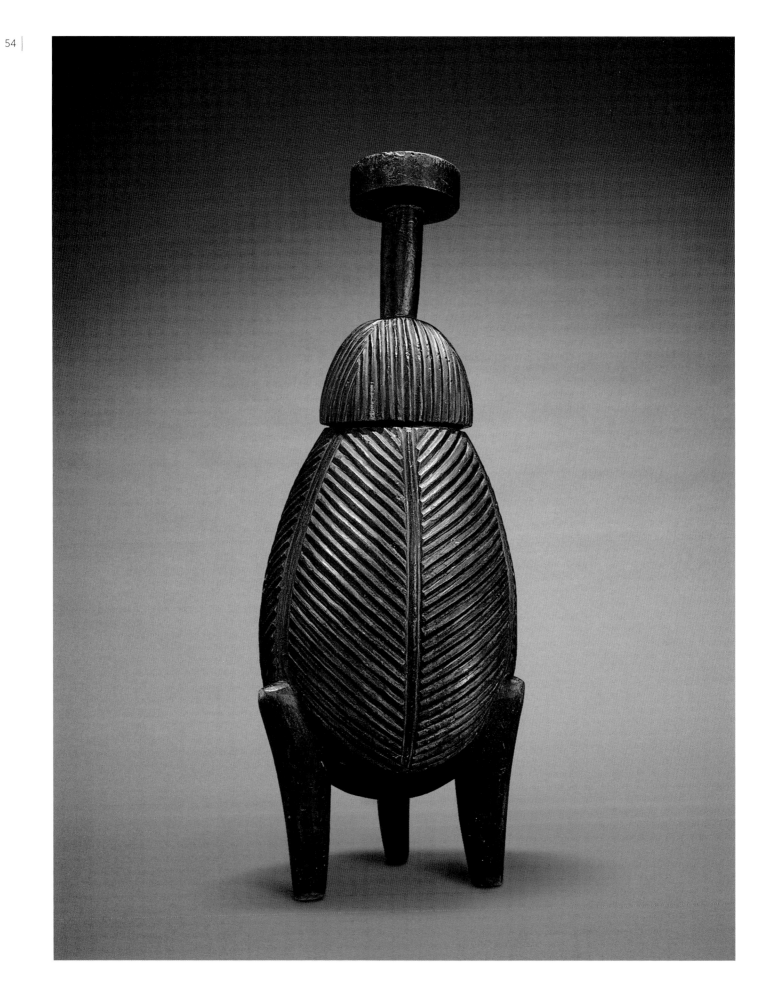

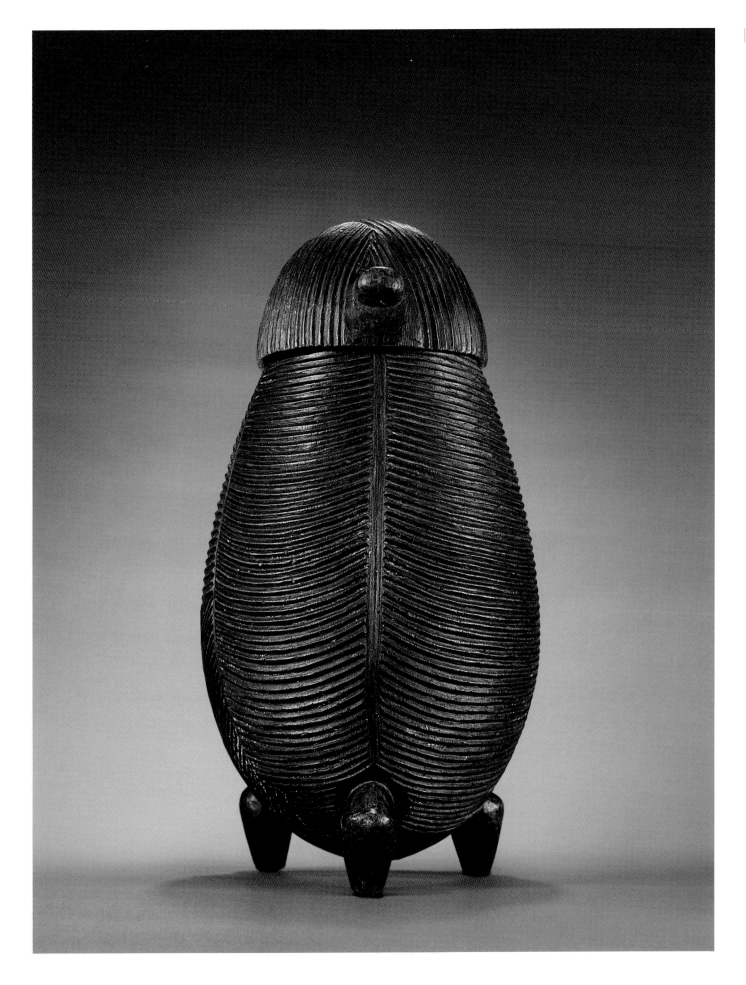

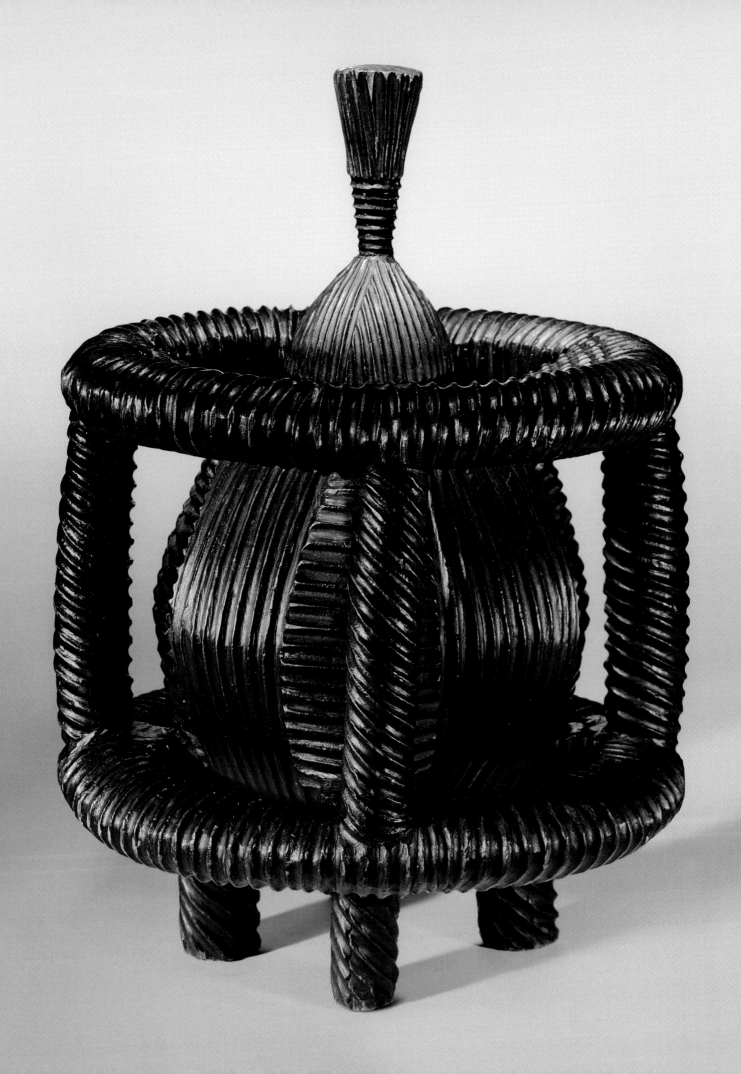

28, 29, 30 **Three**
Lidded Vessels
Swazi, Northern Nguni
or Zulu

31 **Spoon**
Zulu

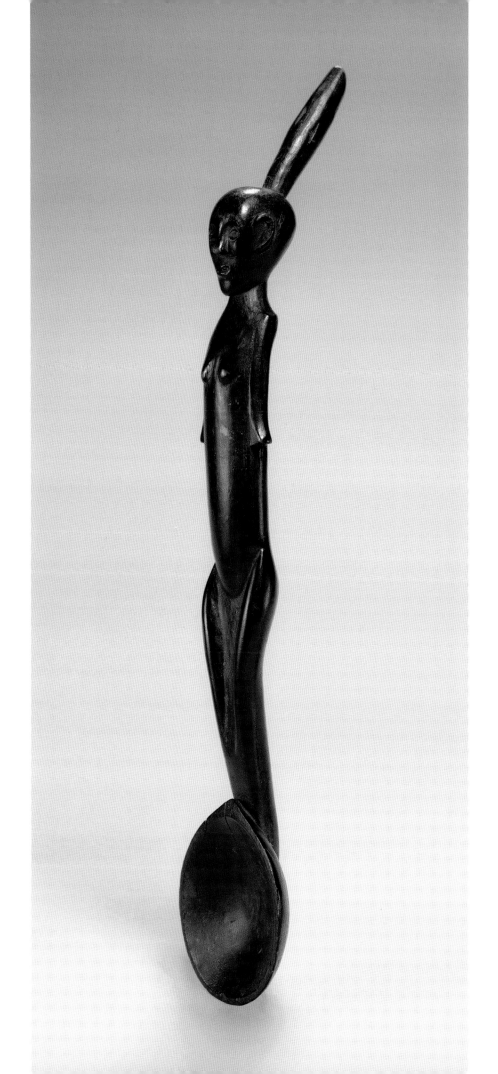

32, 33 Two Snuff Spoons
Zulu

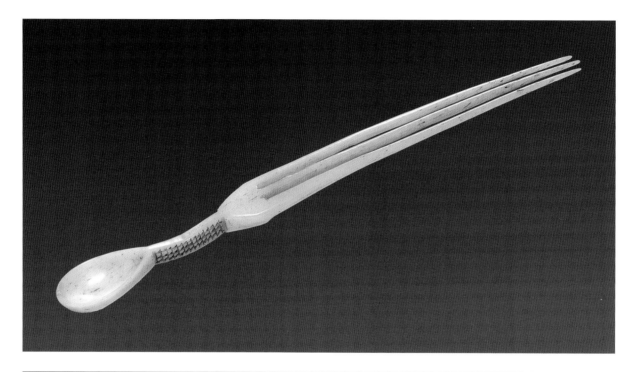

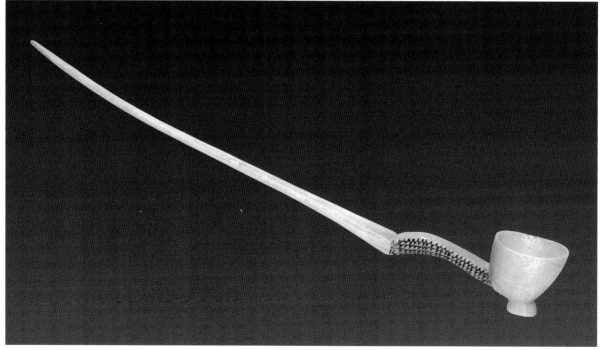

34, 35 **Two Snuff
Spoons/Combs**
Northern Nguni

36, 37,* 38 **Three Spoons**
Zulu

39 **Beer Skimmer**
Zulu

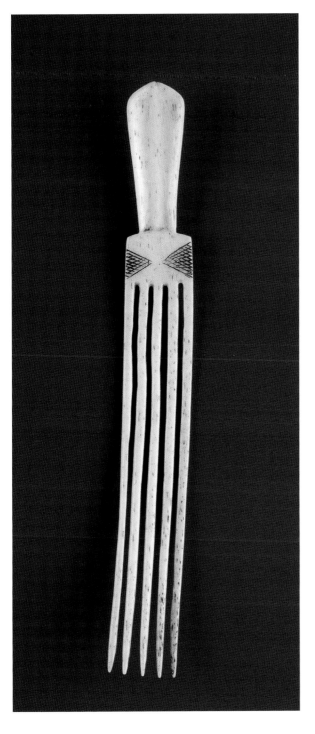

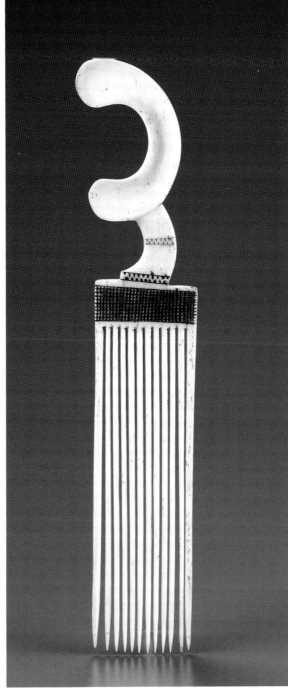

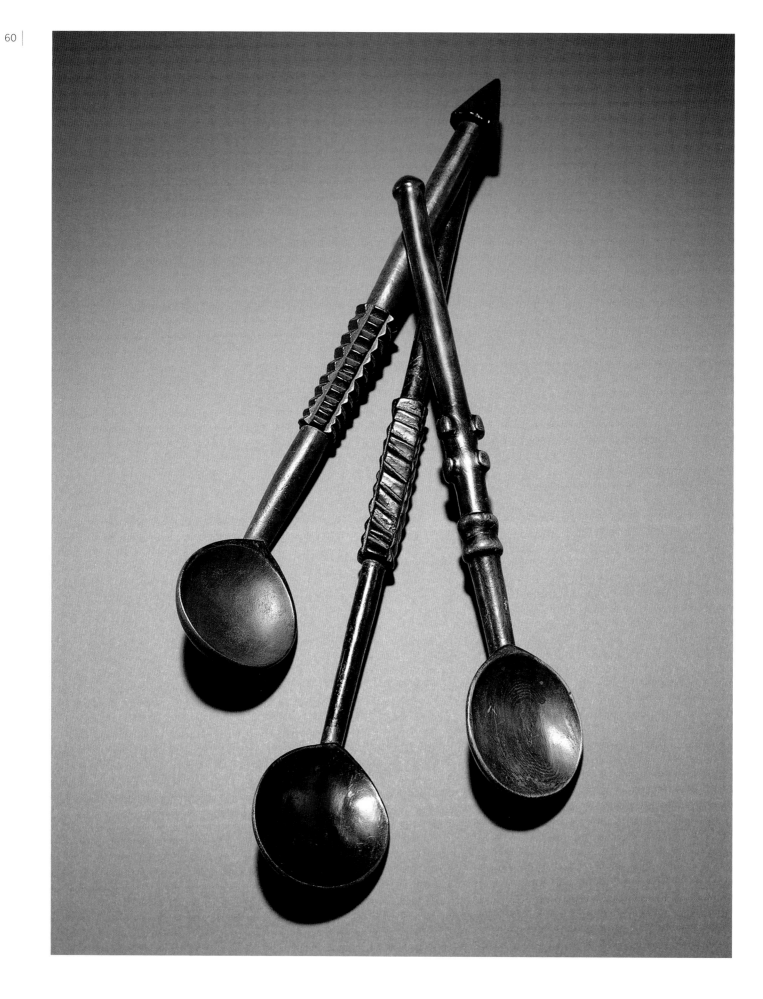

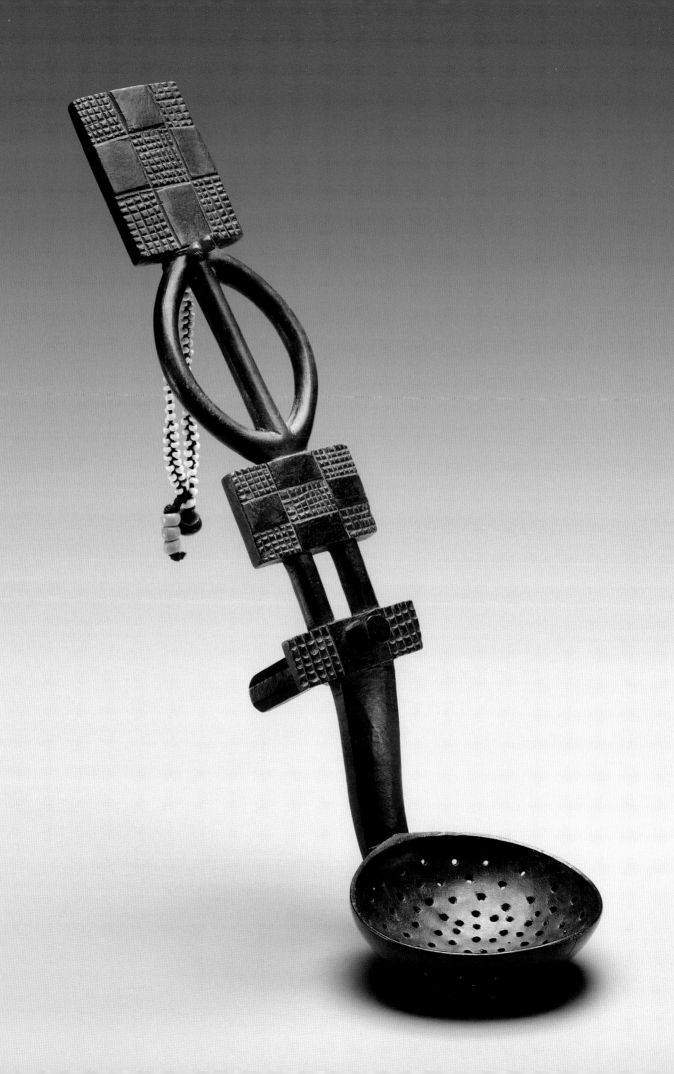

40, 41 Two Vessels
Zulu

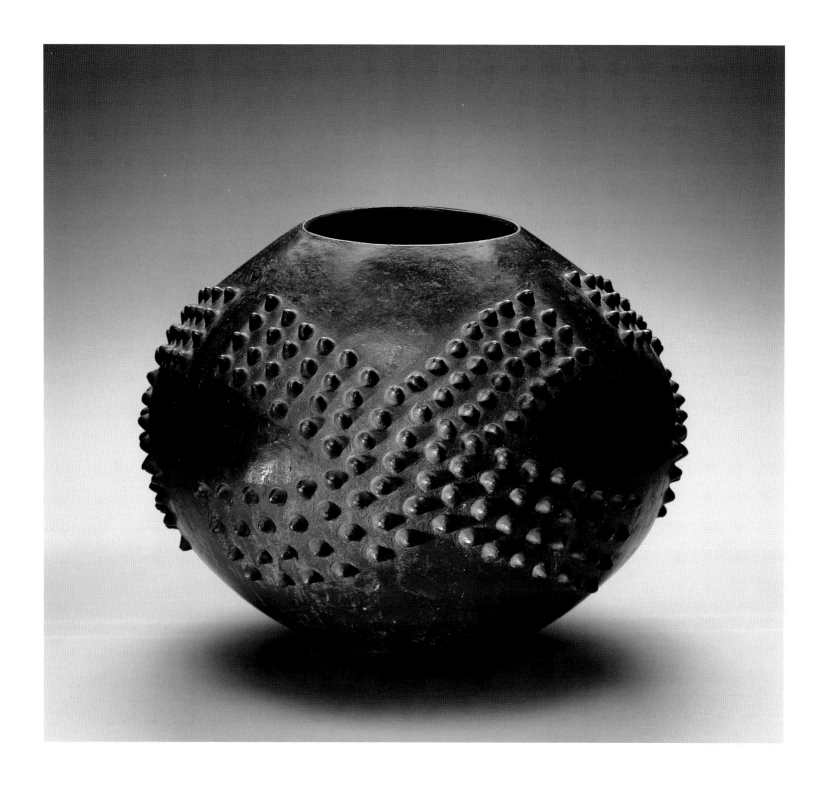

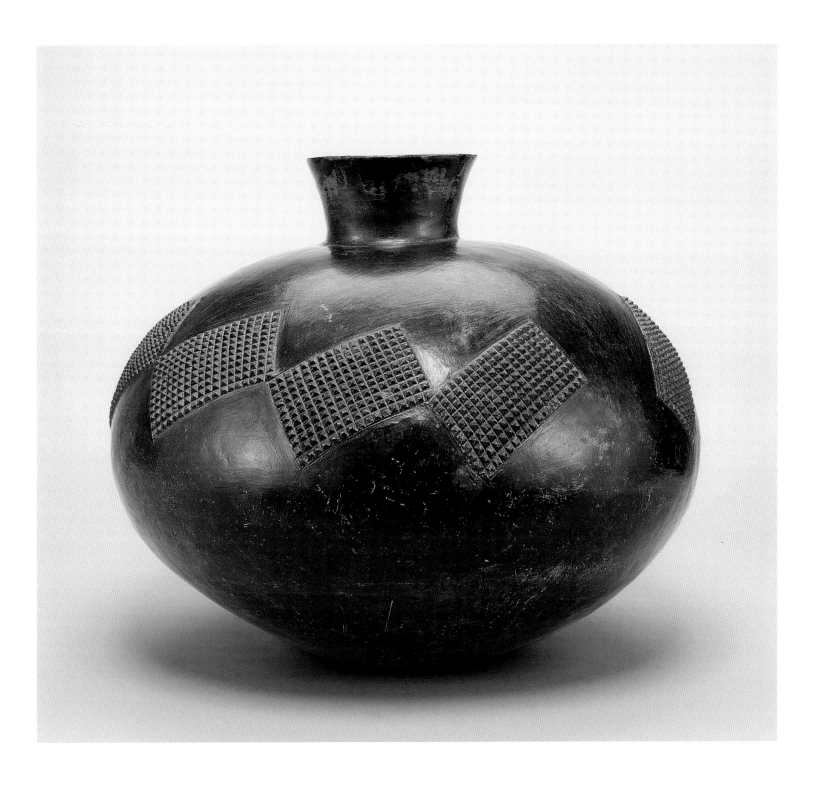

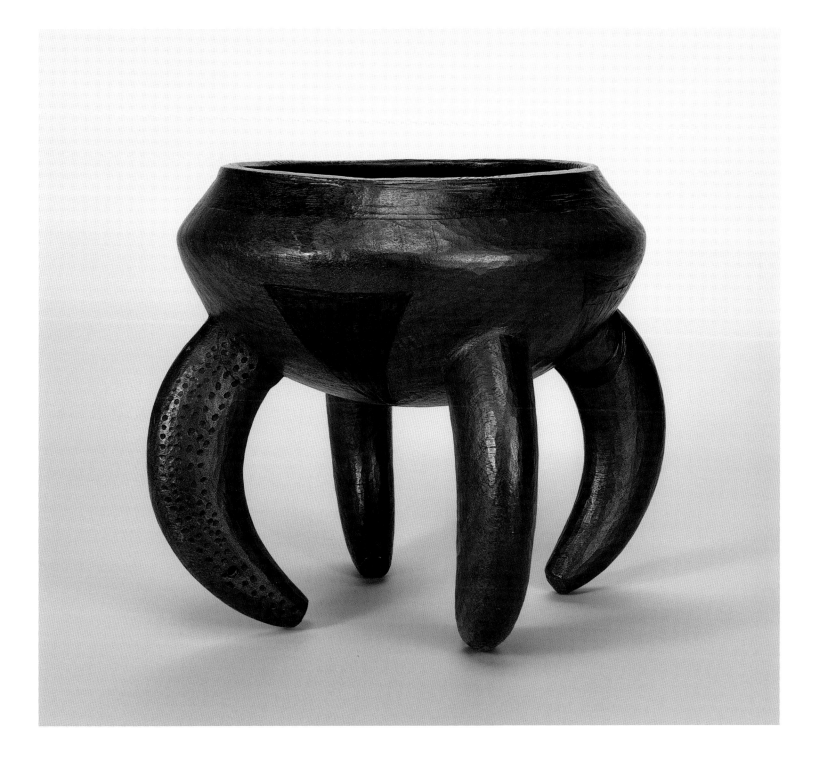

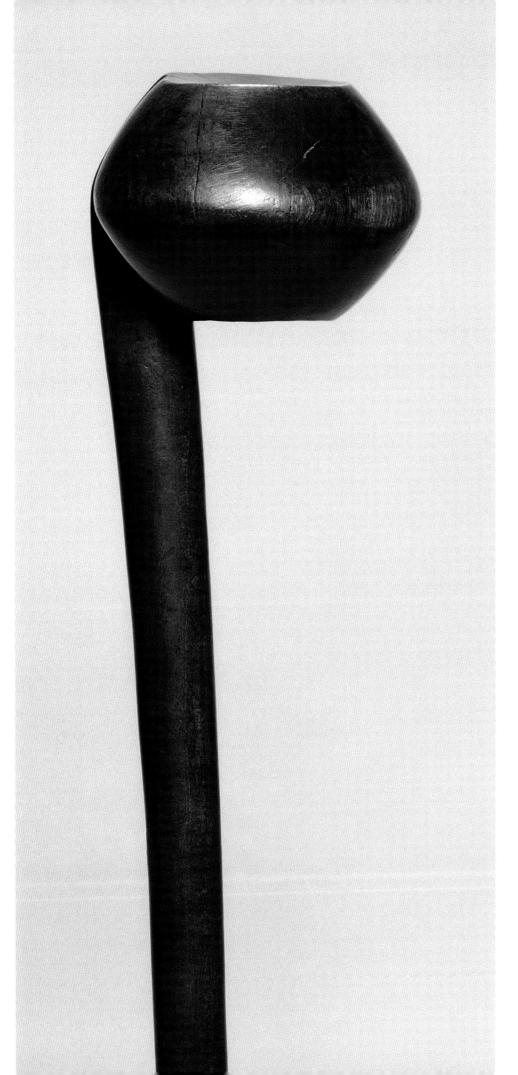

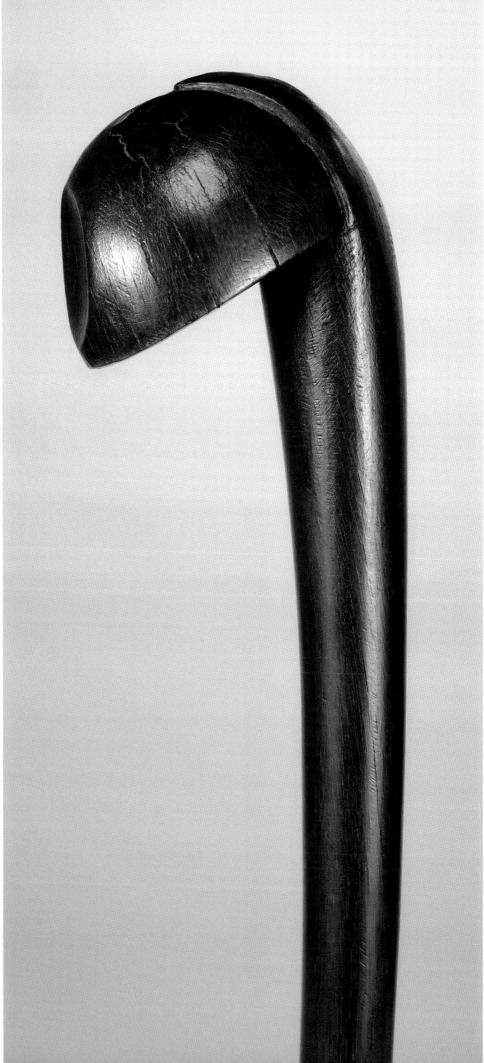

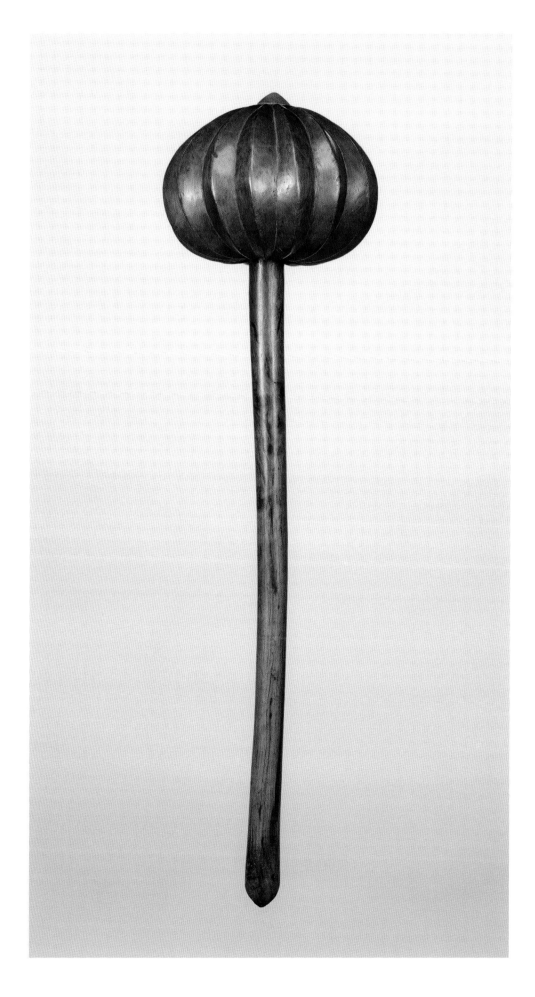

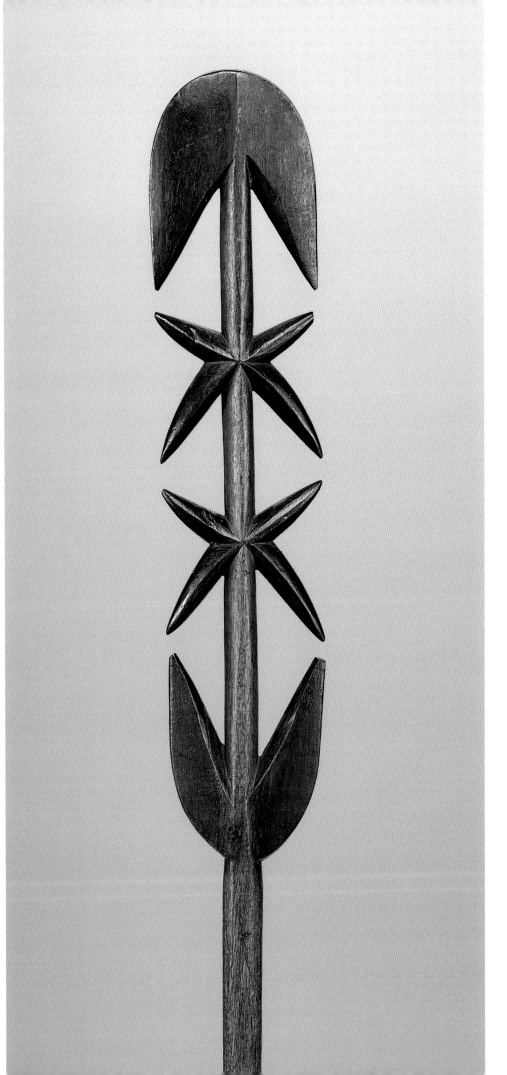

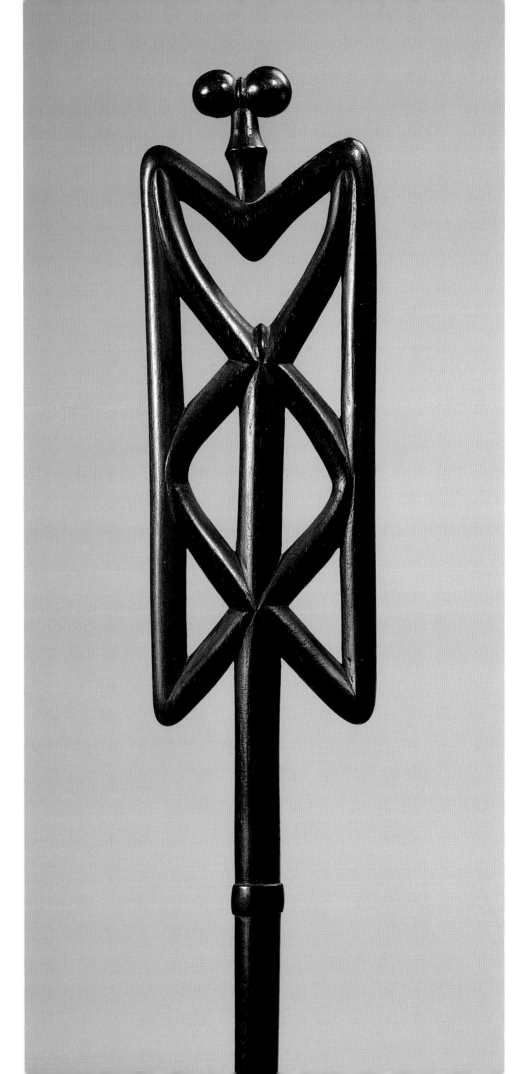

50, 51 Two Prestige Staffs
Northern Nguni |
Tsonga or Zulu

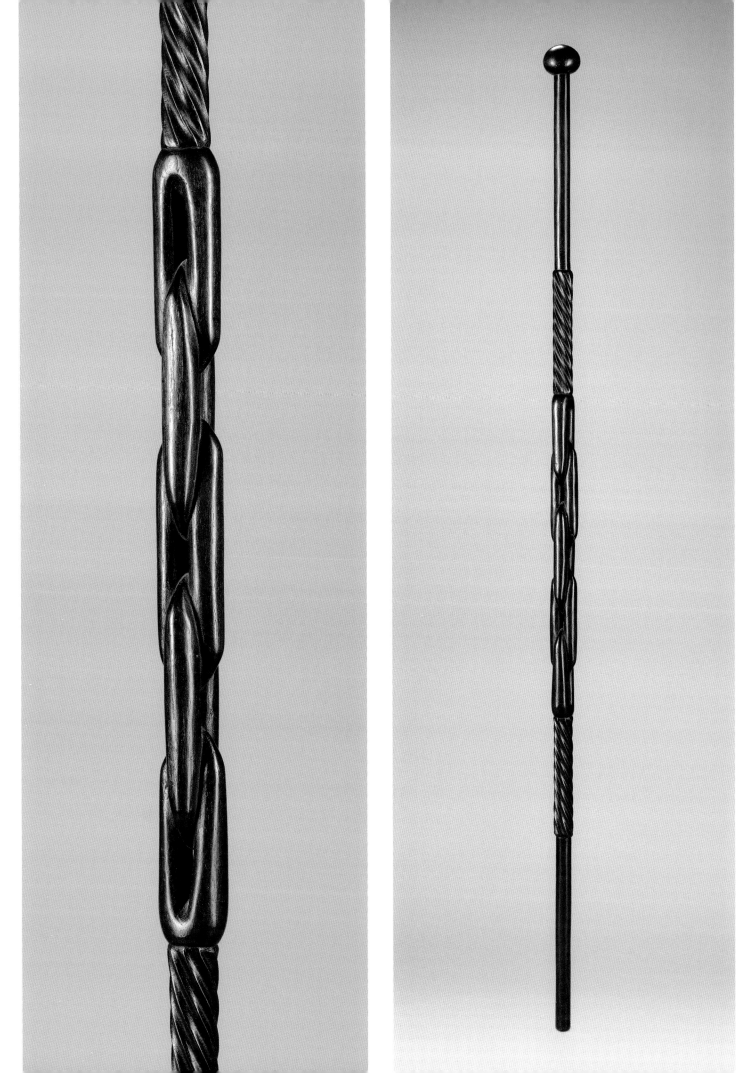

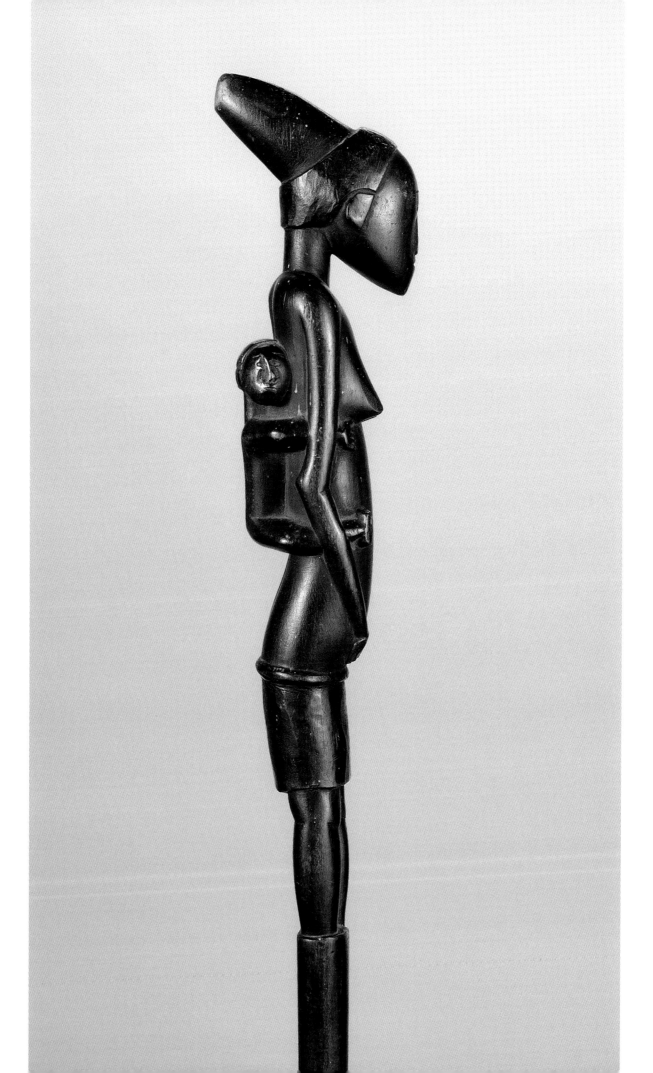

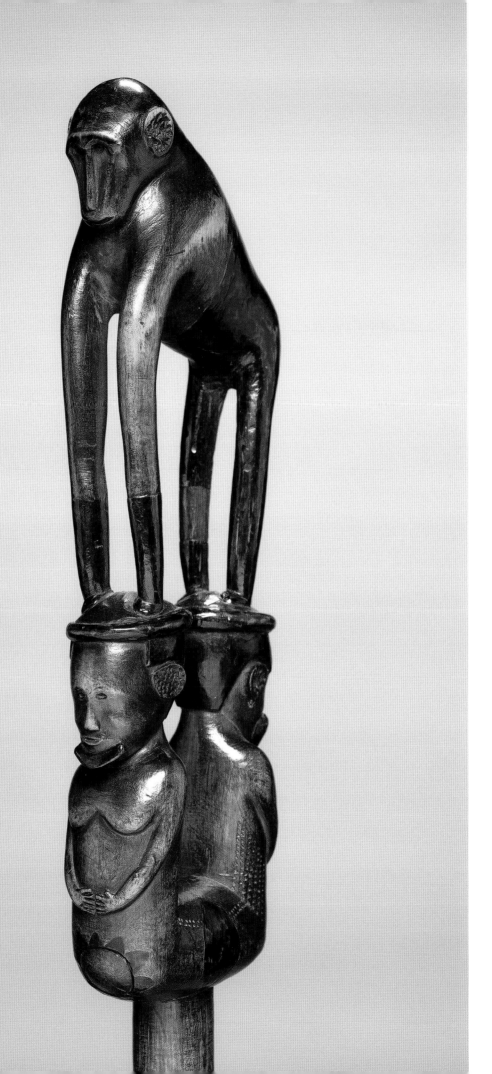

PREVIOUS PAGES
54, 55 Two Staffs
Probably Tsonga

56, 57 Two Staff Finials
Probably Tsonga

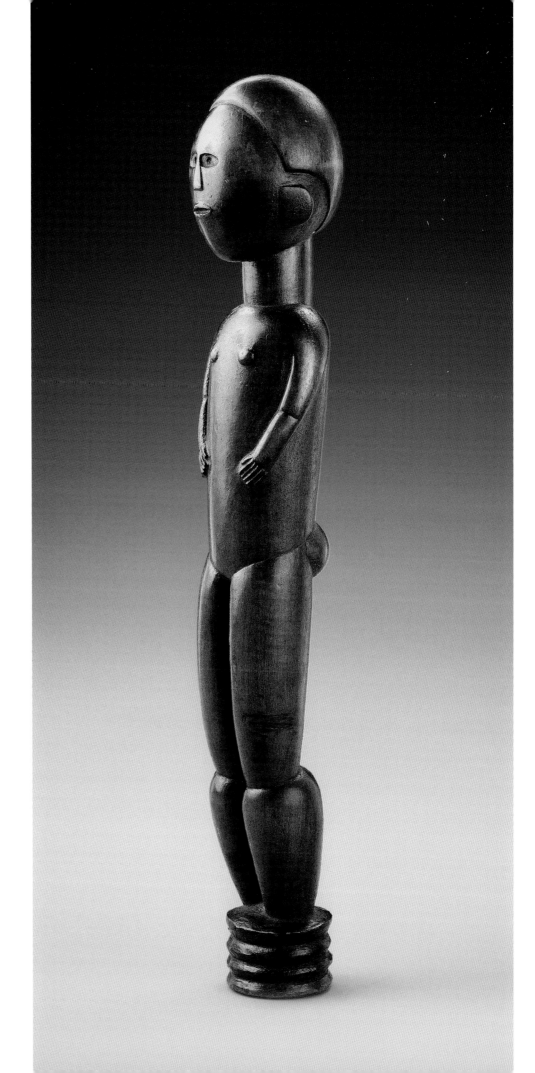

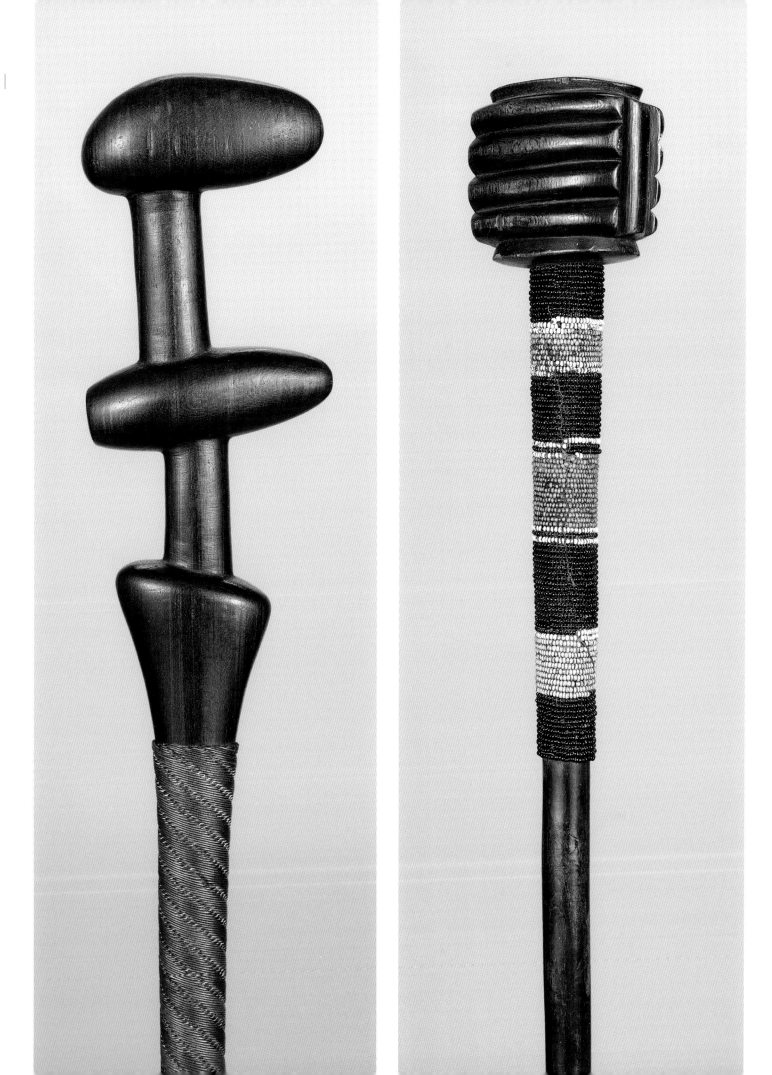

58, 59 **Two Dance Staffs**
Zulu or Tsonga-Shangaan |
Southern Sotho

60* **Axe**
Ndebele (Matabele)
or Shona

81

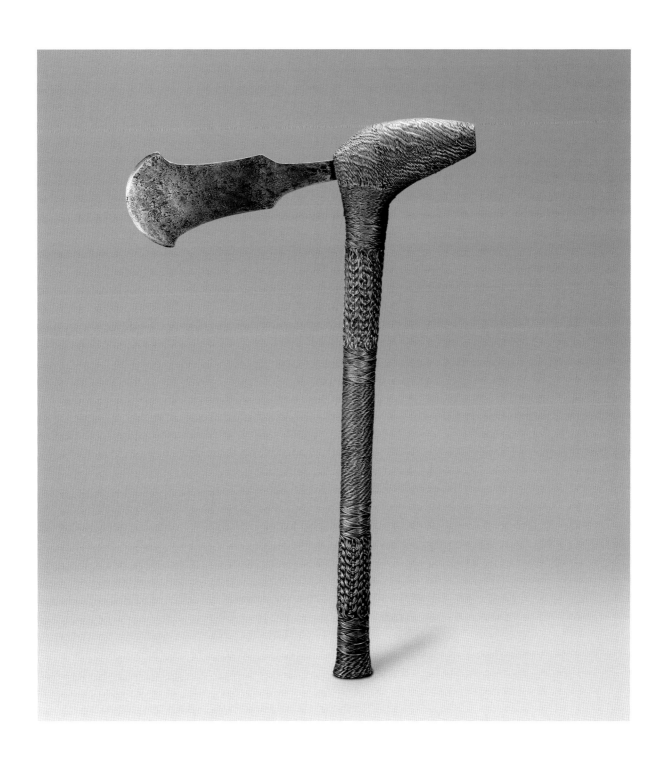

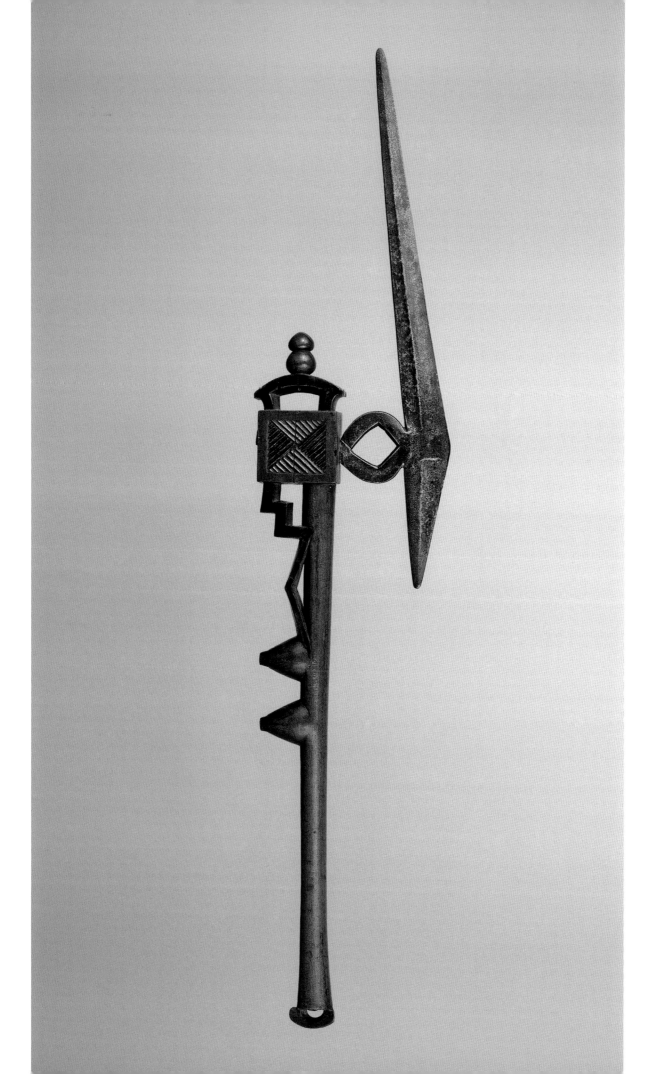

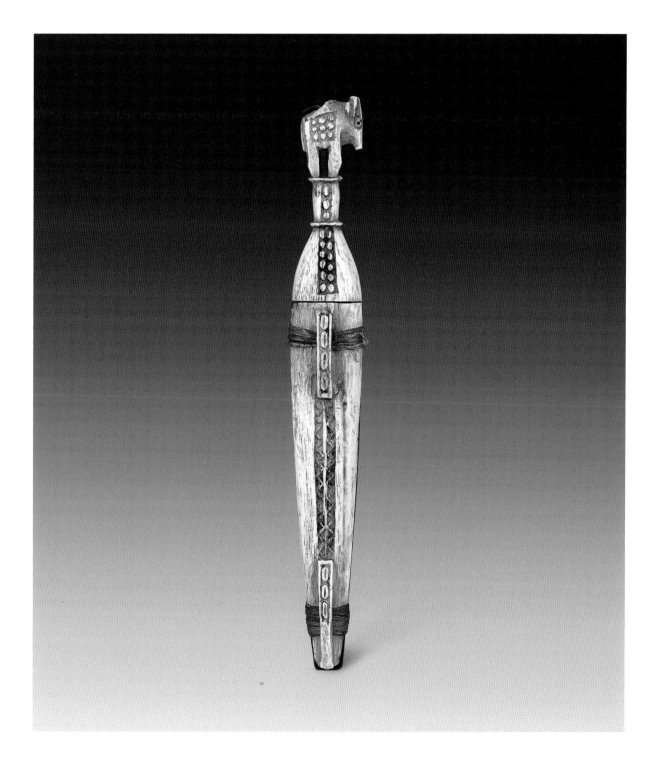

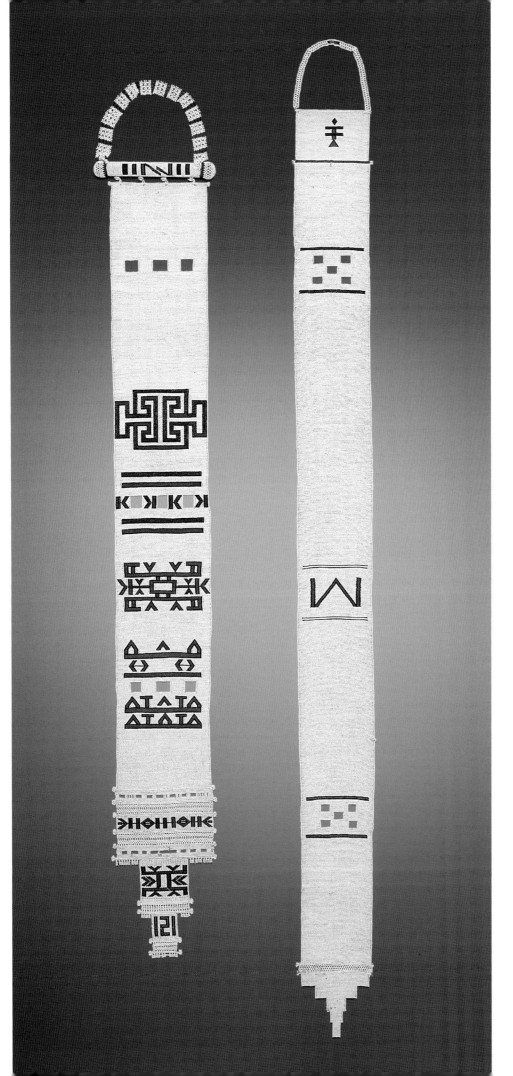

65, 66* **Two Bridal Trains**
Ndebele

68,* 69* Apron and **Belt**
Southern Sotho | Southern Sotho
or Northern Nguni

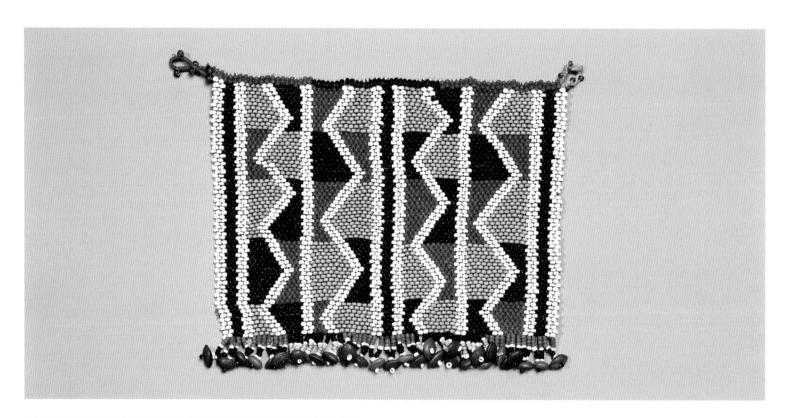

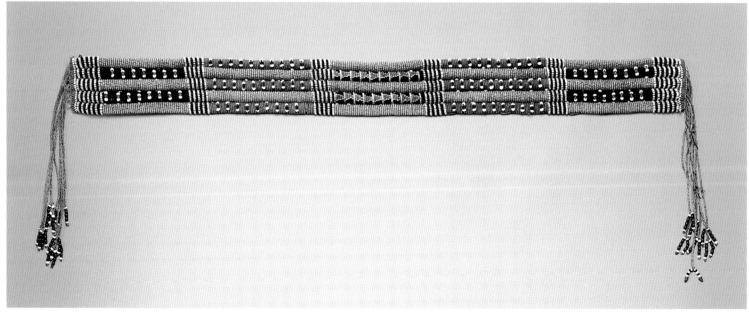

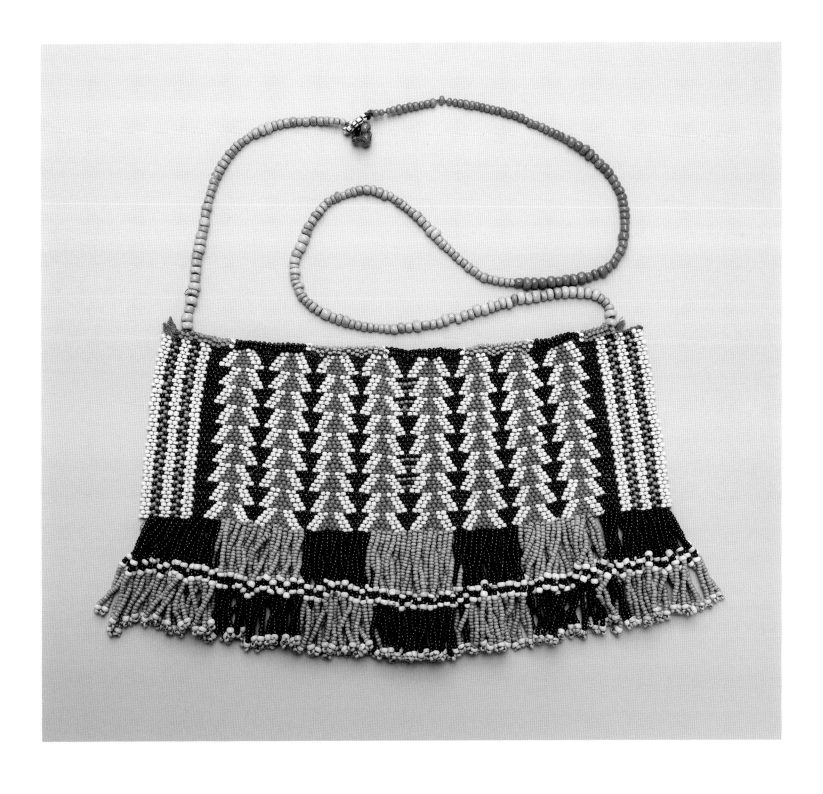

71 Neck Ornament
Northern Nguni

72 Apron
Southern Nguni

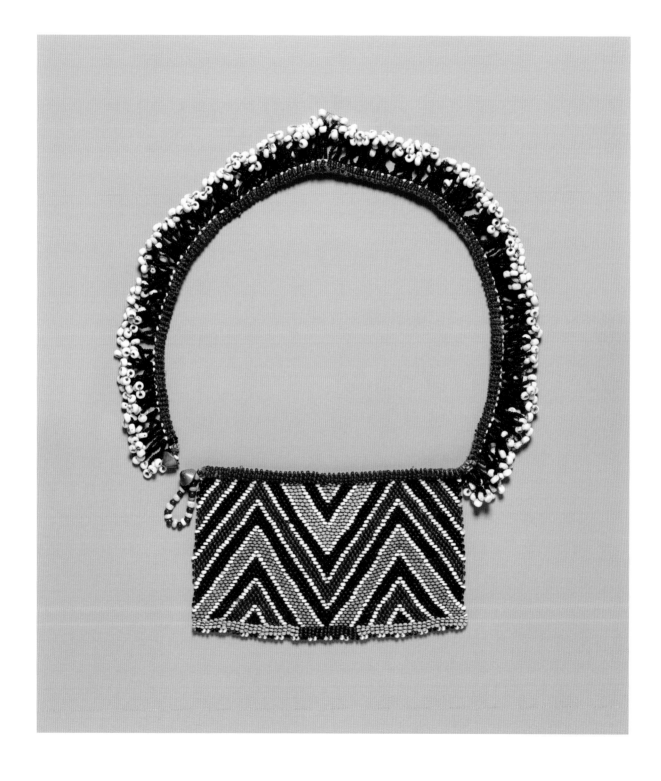

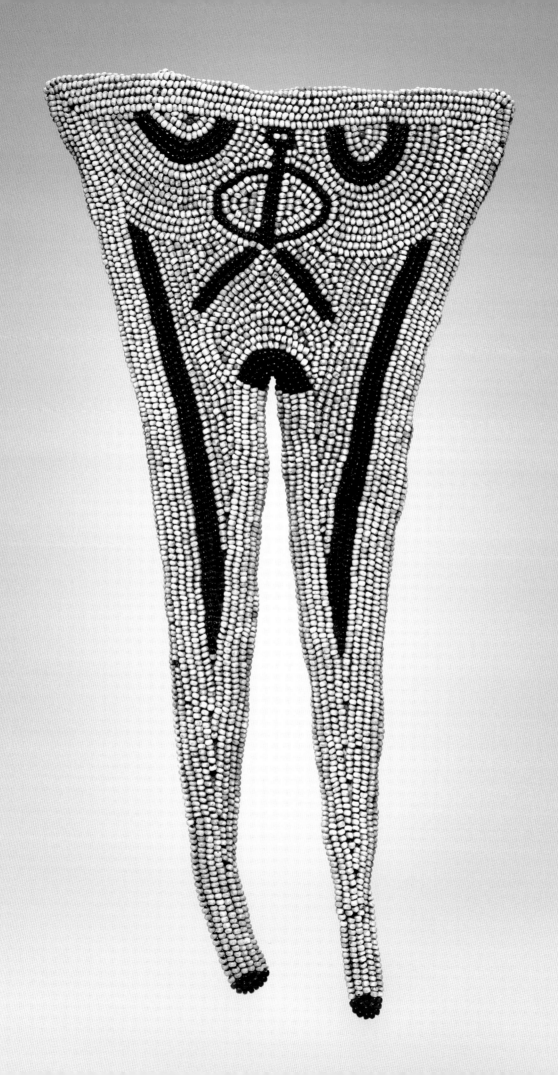

73 Pendant Doll
Xhosa

74 Vest
Mfengu

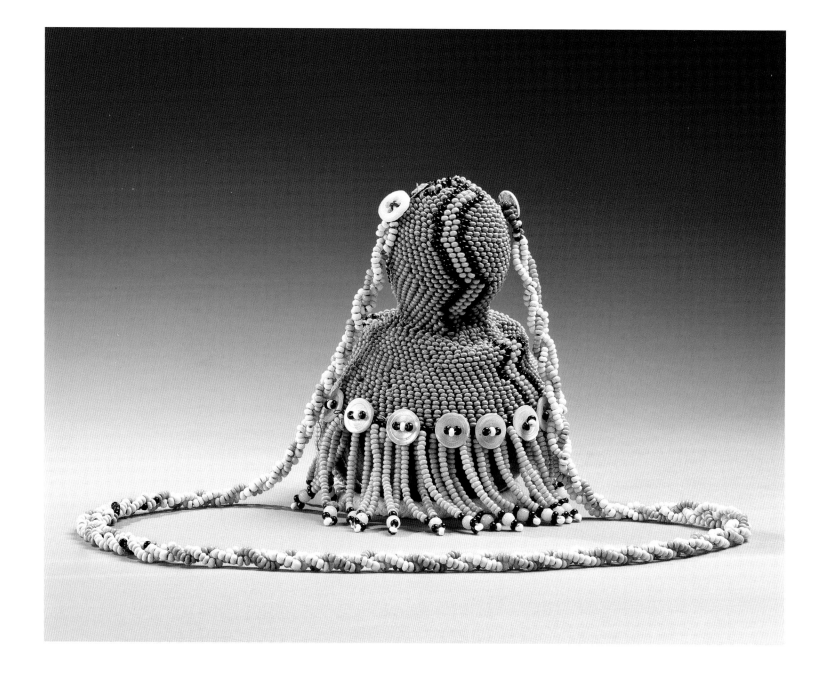

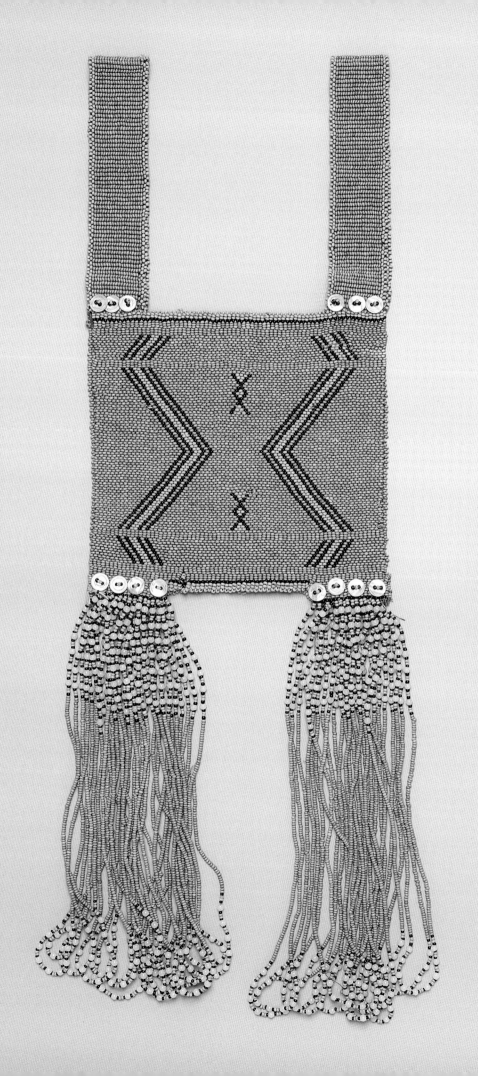

75 Doll (two views)
Ndebele

76 Pendant Doll
Southern Sotho

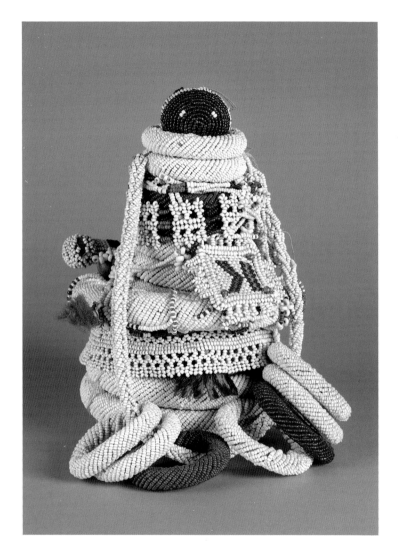

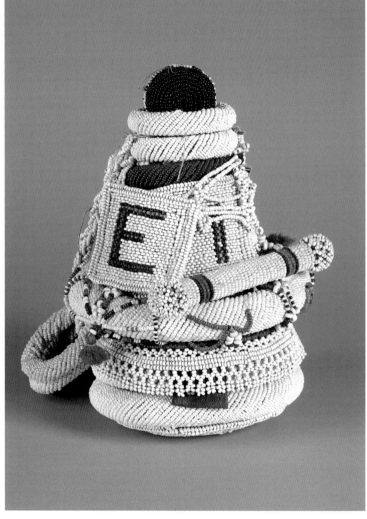

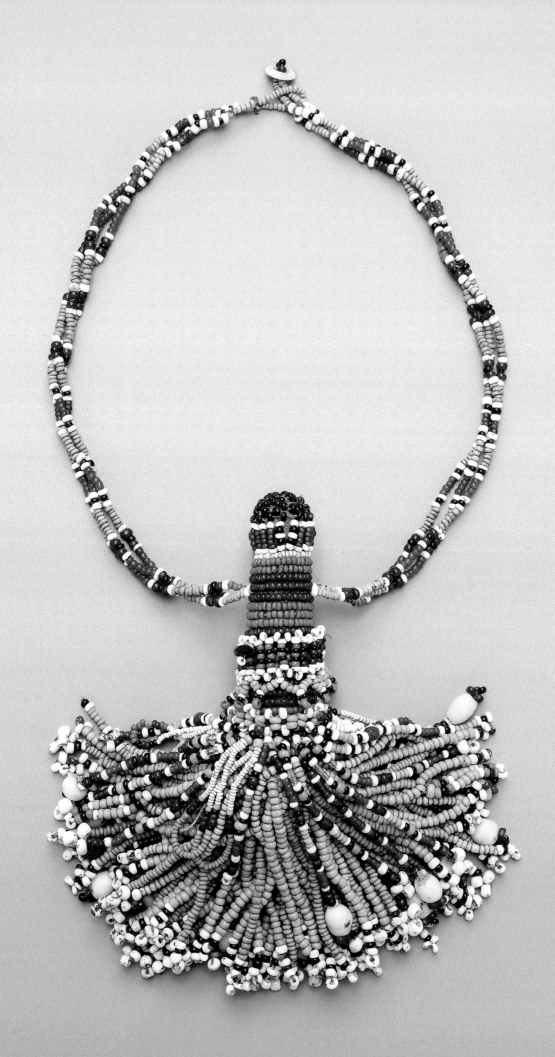

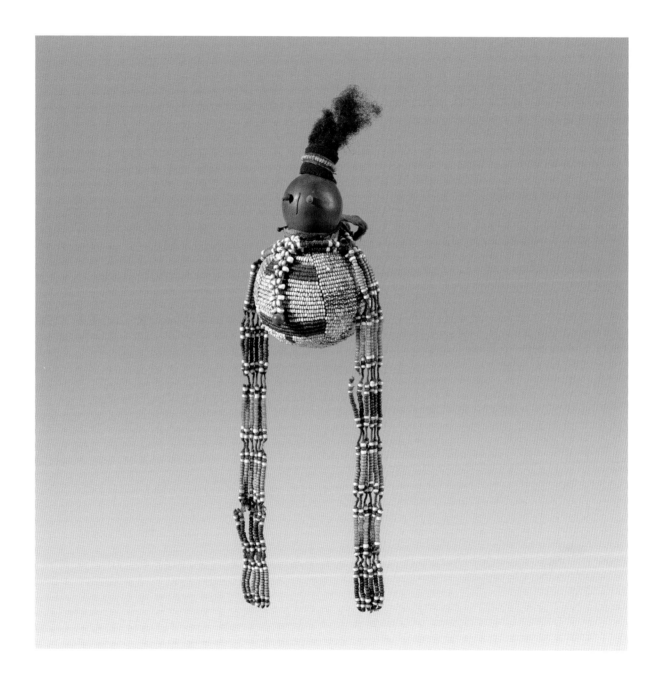

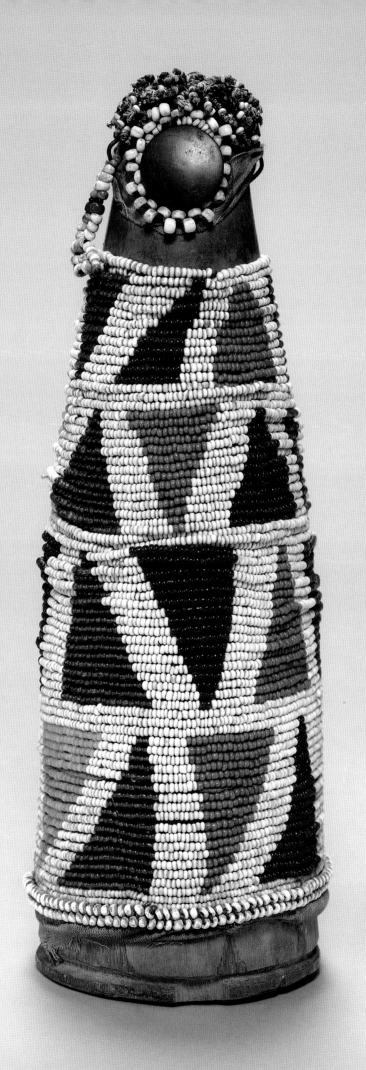

ENTRIES

Unless otherwise noted, all the works included in this publication can tentatively be dated from the mid 19th to the mid 20th century. Many were taken from Africa as souvenirs or as loot by soldiers at the end of the Anglo-Zulu War of 1879 or the South African War of 1899–1901.
* not in exhibition

1 HEADREST

Shona people, Zimbabwe
Wood; H. 14 cm (5½ in.)
Private collection

Continuous handling and use have given this finely carved old headrest a deep brown patina and a shiny surface. Consisting of various incised geometric motifs, it is in a style commonly classified as "Shona." Among the motifs shared in the different examples that constitute endless variations on the same composition, are two circles sandwiched between two sets of open triangles with a central rectangular element running vertically from base to platform. Some have interpreted this particular design as the abstract representation of a squatting human figure without a head, which supports the platform with its upturned arms. The circle motif has led to an identification of the represented figure as female. All the decorative motifs are called *nyora* (scarifications), which were exclusive to women, thus reinforcing the headrest's identity as female. This feminine character underscored the prominence of women in society, even though the headrests were used only by mature Shona men. Cherished personal objects, they were often carried along on journeys and buried with their owners. As pillows, they served to protect the elaborate coiffures highly fashionable until the late 19th century. The use of such headrests also enhanced contact with the ancestral realm through dreams. Interestingly, "when a man marries a woman, the Shona say that he owns her body, but that her head (the seat of her ancestral 'being') belongs always to her father. This clearly refers to the fact that, among the Shona, a woman's fertility is considered to be on loan to her husband's

lineage, of which she never becomes a part" (Anitra Nettleton, in *Africa* 1996: 86).
PROVENANCE
James Willis, San Francisco; Kevin Conru, Brussels; Jacaranda Tribal, New York.

2 ANTELOPE HEADREST

Possibly Tsonga people, South Africa
Wood, glass beads, wildebeest hair, animal teeth; H. 11.4 cm (4½ in.)
Drs. Noble and Jean Endicott

Zoomorphic Tsonga headrests are rare. More typically, animal representations are abstract and indirect, such as in the Zulu and Swazi examples illustrated in these pages. Still, because of the rich diversity in both typology and quality, the attribution to the Tsonga of this particular work remains tentative. Like Shona headrests, most Tsonga pieces have two horizontal planes, a base and a pillow, joined by a vertical support (see also Becker 2002: 163). However, when the support takes the shape of an animal, here what appears to be an antelope, the animal's legs typically replace the base as such. Two additional posts lift the horizontal pillow platform off the animal's back. Strings of blue beads tied around the two columnar extensions add greatly to the appeal of this headrest. Like all headrests, zoomorphic examples serve both as personal utilitarian objects meant to protect the elaborate coiffure of the sleeper and as "dream machines," which metaphysically relate the sleeper to his ancestors (see Nettleton 1990; Becker 1991: 74).
PROVENANCE
Arcade Gallery, London, 1985.

3 HEADREST

Tsonga people, South Africa, or Shona people, Zimbabwe
Wood, glass beads, plant fiber; H. 12.7 cm (5 in.)
National Museum of African Art, Smithsonian Institution, Washington, D.C. (Museum purchase, 89-14-26)

Tsonga and Shona headrest styles are closely related. This example combines typical

Shona traits, such as the rectangular appendages hanging from both ends of the upper platform and the double circle in the form of a figure eight constituting the base, with features that point to a Tsonga origin, such as the supporting column consisting of four evenly spaced cylinders. Like many other seemingly abstract Tsonga and Shona carvings, this headrest bears references to the human anatomy (Nettleton 2007: 131–32). Certain formal characteristics would specifically identify this type of headrest as of female gender. These features include the imitation of a woman's scarification marks on the top ends of the platform, the beaded bands wrapped around the support, and the triangular shapes at the center of the two-lobed base alluding to the female pubis (Lydia Puccinelli, in Walker 1999: 170–71; Karel Nel, in Bassani et al. 2002: 218). In addition to their practical use as pillows meant to help keep elaborate and well-oiled hairstyles intact during sleep, headrests also fulfilled religious and ritual functions. Because they were able to provoke dreams, which are believed to be a source of knowledge required to solve disputes and accomplish other challenging goals, they were part of the paraphernalia of diviners. Exclusively used and owned by men, a headrest was typically buried with its owner or passed on to his descendants. The antiquity of the production and use of headrests can be derived from the presence of their remains in Great Zimbabwe, other ancient ruins, and abandoned burial caves dating to the 12th century (Anitra Nettleton, in Phillips 1995: 204).
PROVENANCE
Dr. Werner Muensterberger, New York, c. 1950–80 to 1989.
PUBLICATIONS
Ravenhill 1991, pl. 4; Walker 1999, cat. 126.

4 HEADREST/STAFF

Tsonga people, Mozambique and South Africa
Wood; L. 61 cm (24 in.)
Private collection, courtesy Donald Morris Gallery, Michigan/New York

The ideal junction of beauty and function receives a striking visual expression in this

object, which combines a headrest and a staff. Such traveling headrests, with the walking stick serving as a carrying handle, epitomize the portable nature of much of the art of the region (Nel 2000: 155). Tsonga carvers in Mozambique and adjacent South Africa are believed to have invented such headrests integrated with staffs in the 19th century. To enhance their portability, these objects are typically compact in size and light in weight.
PROVENANCE
The Old Curiosity Shop, Auckland; Anthony Tobey Jack, London, c. 1955; Merton Simpson, New York; Michael Kan, Detroit. — to 1977.
PUBLICATIONS
Robbins and Nooter 1989, fig. 1271; Sieber and Herreman 2000, cat. 140.

5 DOUBLE HEADREST WITH CHAIN LINKS AND SNUFF CONTAINERS

Tsonga people, South Africa
Wood; H. 15.2 cm (6 in.)
Betsy S. Aubrey and E. Steve Lichtenberg

This type of double headrest is extremely rare. Anitra Nettleton (2007: 132) has noted that absolute bilateral symmetry, as evident in this work, seems to be the hallmark of the design of most southeast African headrests. The fact that the two headrests, links, and containers are all carved from a single piece of wood is a testimony to the virtuosity of the object's maker. The chain is a common theme in Tsonga sculpture of the northeastern Transvaal and Mozambique, and probably refers to past commercial transactions with Portuguese and Arab traders on the east and southeast coast of Africa and their involvement in trafficking human slaves. Both headrests and snuff containers allude to communication with the ancestral world through dreams and tobacco consumption, respectively. However, the imaginative interpretation that double headrests such as this one were used as pillows by a couple, husband and wife, relies on a Eurocentric bias (Becker 1991: 68). It is indeed more likely that they were simply expressions of the good taste of their makers as much as their owners.

PROVENANCE
Private collection, United Kingdom; Jacaranda Tribal, New York.

6, 7 TWO HEADRESTS

Zulu people, South Africa, or Swazi people, Swaziland | Swazi people, Swaziland
Wood; H. 10.2 cm (4 in.) |
Wood; H. 20.3 cm (8 in.)
The Cleveland Museum of Art, Leonard C. Hanna Jr. Fund 2010.198 | Private collection

The shape of these four-legged headrests clearly alludes to cattle, whether bull, ox, or cow. The Swazi example from a private collection, with its characteristic fluting pattern of deeply incised lines on the legs, also shows two tail-like extensions at its short ends and an abdominal appendage or lug in the center of the underside of its platform, which can be read as representing an umbilical hernia or even a phallus (Hooper 1996: 77). The symmetrical ends suggest that two animals are being represented, facing opposite directions but converging at the navel. Similarly, the few examples with multiple pairs of legs evoke the idea of a large herd of cattle. The bovine references in these headrests obviously derive from the fact that these animals are a source of wealth but also act as mediators between the living and the dead. It is not insignificant that in earlier days both headrests and cattle were used in dowry transactions (Sandra Klopper, in Phillips 1995: 207–8; Nel 2000: 154).

PROVENANCE
Cat. 6. Michael Rhodes, New York, 1992; Marc and Denyse Ginzberg, New York, 1992 to 2006; Jacaranda Tribal, New York, 2006 to 2010.
Cat. 7. Steven Alpert, Dallas.
PUBLICATIONS
Cat. 6. Ginzberg 2000, 40.

8,* 9 TWO HEADRESTS

Zulu people, South Africa
Wood; H. 11.4 cm (4½ in.) | Wood; H. 17.8 cm (7 in.)
Private collection

Though carved in classical Zulu style, with the platform resting on six rectangular legs decorated on the exterior sides with broad grooves, cat. 9 is distinguished by its large size. Also unusual are the carved loops on both its short ends, which may have served to suspend the headrest using leather thongs and thus contribute to its portability. Intense usage over time has given the fine, reddish hardwood—a material typically reserved for leaders and other dignitaries—a rich, glossy patina.

PROVENANCE
Private collection, United Kingdom.
PUBLICATIONS
Cat. 9. Brincard 2008, cat. 101.

10 PIPE

Xhosa people, South Africa
Wood, tin, glass beads, sinew, leather;
L. 20.3 cm (8 in.)
The Cleveland Museum of Art, Leonard C. Hanna Jr. Fund 2010.199

The basic form of pipes like this one derives from examples made out of clay, which would have been introduced by the Dutch at the end of the 16th century. Nonfigurative pipes are believed to predate figurative ones (Hooper 2002: 105). Both the long stem and the tall bowl reveal the Xhosa origin of these two works, features that also confirm these pipes were the property of women rather than men. Long-stemmed pipes were often used by mothers of little children because the long stem allowed a mother to keep the smoke away from her baby while carrying it on her back. The color scheme of the beadwork attached to the stem of this pipe also indicates its Xhosa origin. The miniature apron shape suspended from the center of the beaded fringe adds a charming individual touch to this work. Style, decoration, and size were all indicators of a pipe owner's status. Aside from their obvious social and leisure connotations, smoking and snuffing tobacco were also associated with the ancestors and with ideas of fertility and procreation. Inherited among individuals and families, pipes have connected clans and generations, and thus linked the worldly present with the ancestral past.

PROVENANCE
Finch and Co., London, 2004; Jacaranda Tribal, New York, 2004 to 2010.
PUBLICATIONS
Pemberton 2008, cat. 114.

11 BUFFALO PIPE

Xhosa people, South Africa
Wood, lead; l 14.6 cm (5¾ in.)
Harry and Diane Greenberg

Continuous handling over time has darkened the light color of the wood from which this pipe was carved and given it a deep, glossy patina. The object is strikingly unusual for its general figurative shape and complex decorative lead inlay work, and exceptional for the finesse of its sculpture. The bowl is carved with extreme precision in the form of the head of what seems to be a Cape buffalo (*Syncerus caffer*), its curved horns and facial features carefully rendered with special attention to detail. While cattle were typically represented in a more abstract or stylized manner in the visual arts, their cultural significance has been well documented throughout southern Africa. Not only were cattle important from an economic standpoint, they also played a vital role in communications between the living and the dead. It is no coincidence that tobacco and snuff were also given as marriage gifts and that "because of its capacity to heighten awareness and increase sexual arousal, tobacco became associated with procreation, fertility and access to the ancestors" (Nel 2000: 28). The striking surface decoration with lead inlay on both sides of the plane between the bowl and the stem is a design representing two ostriches, something rarely seen in the traditional arts of southern Africa. The practice of decorating pipes with lead inlay may have been inspired by European examples. Interestingly, lead was considered a powerful material since it was salvaged from bullets.

PROVENANCE
Jonathan Lowen, London; Colin Sayers, Cape Town, — to 2007; Sotheby's (Paris), 2007; Jacaranda Tribal, New York.
PUBLICATIONS
Sotheby's 2007b, lot 100c.

12 PIPE

Xhosa people, South Africa
Wood, iron, copper alloy;
L. 19.7 cm (7¾ in.)
National Museum of African Art, Smithsonian Institution, Washington, D.C. (Museum purchase, 89-14-17)

Although always carved by men, pipes were used by both genders. Typically made of a dense and dark wood, pipes were especially popular among the Nguni-speaking people of the Eastern Cape and their Sotho-speaking neighbors in Lesotho (Karel Nel, in Phillips 1995: 211). Like some of the other pipes in this publication, this one, with double bowls, is also subtly decorated with appliquéd metalwork, specifically three bands of woven copper alloy and iron. The pipe's considerable wear and tear is an obvious sign of intense use. As prized family heirlooms, pipes were often passed down from one generation to the next and, over time, used only on special occasions.

PROVENANCE
Dr. Werner Muensterberger, New York, c. 1950–80 to 1989.
PUBLICATIONS
Ravenhill 1991: pl. 8.

13 PIPE

Xhosa people, South Africa
Wood, metal; L. 13.3 cm (5¼ in.)
National Museum of African Art, Smithsonian Institution, Washington, D.C. (James Smithson Society, 89-8-23)

The vertical design element in this pipe, which serves as a conduit for smoke between the stem and the bowl, vaguely looks like a bent human leg and may add a humorous twist to the sculpture, a not uncommon feature for pipes from the Eastern Cape. Pipes were often given as wedding presents or as gifts to maintain harmonious family or kinship ties.

PROVENANCE
Allegedly acquired in South Africa in 1865; Michael Graham-Stewart, London, — to 1989.
PUBLICATIONS
Ravenhill 1991: pl. 8.

14 PIPE

Southern Nguni people, South Africa,
or Southern Sotho people, Lesotho
Wood, iron; H. 37.5 cm (14¾ in.)
National Museum of African Art,
Smithsonian Institution, Washington,
D.C. (Museum purchase, 89-14-16)

Missing its stopper, which was most likely
carved in the shape of a woman's head,
this figurative pipe was either made by an
artist of the Southern Nguni or the neigh-
boring Southern Sotho. Philip Ravenhill (in
Walker 1999: 176) eloquently described this
superb sculpture as follows: "The artist has
brilliantly conceived the bowl of the pipe
as a long and subtly elegant female torso.
The long arms are held at waist level and
tight to the body, just above the delicately
carved navel. The sharp lines of the sepa-
rately carved stem, inserted into the lower
back, emphasize the curves of the hips and
buttocks. The tapered legs and diminutive
feet are angled forward, echoing the for-
ward thrust of the arms and reflecting the
sense of the figure as a vibrant body at
rest." Although used by both men and
women, pipes were typically made by male
artists. The pipe's aesthetic excellence,
expressed in its design as much as in its
craftsmanship, reinforces the belief that
tobacco products were associated with gen-
erous and powerful humans and ancestral
spirits alike (Karel Nel, in Phillips 1995: 211).

PROVENANCE
Norman Hurst, Cambridge, Mass., — to
1984; Dr. Werner Muensterberger, New
York, 1984 to 1989.

PUBLICATIONS
Berjonneau and Sonnery 1987, fig. 291;
Ravenhill 1991, pl. 7; Phillips 1995, cat. 3.29b;
Walker 1999, cat. 131.

15, 16, 17 THREE SNUFF CONTAINERS

Undetermined ethnic origin,
southern Africa
Gourd, brass and copper wirework;
H. 6 cm (2⅜ in.) | Gourd, brass
and copper wirework; H. 5.7 cm (2¼ in.) |
Gourd, brass and copper wirework;
H. 7.5 cm (3 in.)
National Museum of African Art,
Smithsonian Institution, Washington,
D.C. (James Smithson Society, 89-8-28)
| National Museum of African Art
(James Smithson Society, 89-8-30) |
The Cleveland Museum of Art, Leonard
C. Hanna Jr. Fund 2010.200

Although they are commonly ascribed to
the Zulu, snuff containers made out of a
gourd—the dark hard shell of the fruit of
the *Oncoba spinosa* tree (Carolee Kennedy
and William Dewey, in Greub 1988: 100)—
and decorated with brass and copper
wirework were in fact widespread in
southern Africa. It is impossible to relate
specific patterns of the wirework decora-
tions to a particular region or ethnic group
(Kevin Conru, in Klopper and Nel 2002:
202, pl. 55; 205, pl. 63). While the phallic
shape of elongated snuff containers made
out of "male materials" such as wood and
horn were typical men's possessions, the
shape and material of gourd snuff con-
tainers suggest they would have been
made for female users. Like a woman's
womb, the gourd's form was the container
and nurturer of the seed (Nel 2002: 28).
The materials and the forms of snuff con-
tainers allude to procreation and fecun-
dity. It is no coincidence that gourds were
often used to make child figures such as
the remarkable examples illustrated in this
volume (cats. 73, 77). In addition to their
power to stimulate sexual arousal, snuff
and tobacco were also believed to enable
communication between humans and
ancestors. Indeed, throughout southern
Africa snuff was and is among the most
popular offerings to the ancestors.

PROVENANCE
Cat. 15. R. de Porre, Durban, South Africa;
Michael Graham-Stewart, London, — to 1989.
Cat. 16. Michael Graham-Stewart, London,
— to 1989.
Cat. 17. Marc and Denyse Ginzberg, New
York, 1981 to 2007; Sotheby's (Paris),
2007; Jacaranda Tribal, New York, 2007 to
2010.

PUBLICATIONS
Cat. 15. Ravenhill 1991, pl. 5; De Smet 1998,
pl. 66a.
Cat. 16. Ravenhill 1991, pl. 5; De Smet 1998,
pl. 66a.
Cat. 17. Klopper 1998, cover; Ginzberg
2000, 120; Sotheby's 2007a, lot 96.

18, 19 TWO SNUFF CONTAINERS

Zulu people, South Africa | Shona
people, Zimbabwe
Horn; H. 8.9 cm (3½ in.) | Wood, reed,
copper alloy; H. 5.4 cm (2 1/8 in.)
National Museum of African Art,
Smithsonian Institution, Washington,
D.C. (Museum purchase, 89-14-14
and 89-14-11)

A preparation of powdered and processed
tobacco, snuff has been widely used in
Africa since the introduction of tobacco on
the continent by Europeans in the 16th
century. With the aim to establish or solidify
harmonious social relationships, it was
typically offered to visitors and shared
among friends. The Zulu example with
conical projections imitates a seed pod
(cat. 18). Since its basic form suggests a
natural form, this snuff container can be
labeled a *skeuomorph*. The same is true
for the spherical Shona snuff container
made of wood (cat. 19). Its narrow cylin-
drical neck, stopped with a piece of reed
and a C-shaped suspension lug on one
side, is finely decorated with linear relief
patterns on its body and copper wire tied
around its neck. As Philip Ravenhill (1991:
18) has pointed out, "such objects allow a
double appreciation: the form that is per-
ceived and the form that is echoed."

PROVENANCE
Dr. Werner Muensterberger, New York,
c. 1950–80 to 1989.

PUBLICATIONS
Cat. 18. Ravenhill 1991, pl. 6.

20 SNUFF CONTAINER

Shona people, Zimbabwe
Wood, brass wire; H. 21 cm (8¼ in.)
Rosemary and Michael Roth

Throughout southern Africa, as elsewhere
on the continent, smoking tobacco and
taking snuff are enjoyed as activities that
enhance positive social relationships. Snuff
containers are among the smallest portable
personal objects made and used in the
region (Karel Nel, in Phillips 1995: 214).
Worn by men and women alike, they were
attached to cloaks, carried in bags, or
adorned the neck, arm, or waist. They show
a striking variety of forms, with styles rang-
ing from austere abstraction to stylized fig-
uration. This most elegantly shaped snuff
container has a lustrous patina and soft
edges resulting from repeated wear and
handling. The artist who carved it suc-
ceeded in creating an illusion of different
colors of wood through the finely grooved
surface pattern. The wirework decoration
around its neck shows a similar contrast,
derived from the use of two tones of brass.
The adornment of a personal wooden
implement with brass wirework not only
enhanced its visual appeal and reinforced
its structure, it also added significantly to
the work's value as a symbol of prestige
and social standing.

PROVENANCE
Michael Graham-Stewart, London; Colin
Sayers, Cape Town, — to 2007; Sotheby's
(Paris), 2007; Jacaranda Tribal, New York.

PUBLICATIONS
Sotheby's 2007b, lot 100a.

21 SNUFF CONTAINER

Northern Nguni people, South Africa
Wood, glass beads, nut shell, cotton
thread; H. 20.3 cm (8 in.)
The Cleveland Museum of Art, Leonard
C. Hanna Jr. Fund 2010.201

Combining beauty and functionality, this
finely carved wooden snuff container is
adorned with twisted strands of colorful
glass beads. It was at once an object of sta-
tus, signaling the wealth and taste of its
owner, and an item of adornment that
would have been part of a larger ensemble
of beaded garments and accessories. Its
general shape and the design of parallel
fluted ridges cut into the wood seem to
imitate a winged fruit, making it a *skeuo-
morph*. In copying the design of another
artifact in another material, it also testifies
to the skills of its maker.

PROVENANCE
Christie's (Paris), 2006; Jacaranda Tribal,
New York, 2006 to 2010.

PUBLICATIONS
Christie's 2006, lot 227; Pemberton 2008,
cat. 93.

22 SNUFF CONTAINER

Southern Sotho people, Lesotho
Horn; H. 40.6 cm (16 in.)
National Museum of African Art,
Smithsonian Institution, Washington,
D.C. (Museum purchase, 89-14-1)

Most probably made from cattle horn by a
male artist, this most elegant snuff con-
tainer topped with a stopper is one of a
small number of similar works to have
come down to us. The austerity of its form
and the brilliance of its patina are among
the quintessential traits of the greatest
examples of portable art of southern Africa.
Although seemingly abstract in shape,
horn snuff containers such as this one
would have been inspired by the pin-tailed
whydah, or widowbird (*Vidua macrura*), a
small black bird with long white and black
tail feathers. The use of cattle horn for
these distinctive snuff containers denotes
the connection between cattle as a source
of wealth and the ancestral connotations
of tobacco snuffing (Karel Nel, in Phillips
1995: 213). The tail-like extensions made it
possible, in principle, to carry such contain-
ers in the hair, through a pierced earlobe,
or suspended from the neck or waist.
However, the shape and size of the extension
in this example precluded its secondary
use as a hair or body ornament. Perhaps
the spatula-shaped blade indicates that

instead it served as a sweat scraper in addition to as a snuff container. Testifying to its maker's extraordinary skills and care, it was most likely primarily an ostentatious display piece created for a chief or another individual of high rank.

PROVENANCE

Dr. Werner Muensterberger, New York, c. 1950–80 to 1989.

23, 24* TWO SNUFF CONTAINERS

Southern Sotho people, Lesotho
Horn; H. 10.8 cm (4¼ in.) | Horn, wood; H. 20.3 cm (8 in.)
The Cleveland Museum of Art, Leonard C. Hanna Jr. Fund 2010.202 | Private collection

These two snuff containers—the black one in the form of a human figure and the cream colored of an animal, most likely an antelope—were carved from cattle horn. In both cases the form of the image follows the curve of the horn, with arms and hands held to the chest in the case of the anthropomorphic container. Despite their smallish size and minimalist execution, these objects demonstrate considerable expressive power. Cattle had special meaning for the pastoral peoples of southern Africa in that the animals stood for the wealth and status of the individual and the group (Karel Nel, in Phillips 1995: 213; Nel, in Bassani et al. 2002: 228). However, similar to the ideas associated with tobacco and snuff, cattle also referred to the world of the ancestors. Snuff containers like the ones represented here therefore had great significance for their owners and users.

PROVENANCE

Cat. 23. Steven Alpert, Dallas, 2005; Jacaranda Tribal, New York, 2005 to 2010.
Cat. 24. Jonathan Lowen, London; Bowmint Collection, Pretoria; Jacaranda Tribal, New York.

25, 26 TWO SNUFF CONTAINERS

Zulu people, South Africa | Possibly Northern Nguni people, South Africa
Gourd, glass beads, plant fiber; H. 14 cm (5½ in.) | Gourd, glass beads; H. 9.5 cm (3¾ in.)
National Museum of African Art, Smithsonian Institution, Washington, D.C. (James Smithson Society, 89-8-25) | Patricia and Robert Weiner

These two glass bead–covered gourds illustrate yet another type of snuff container. The design arrangements and the color patterns of the delicate beadwork may point to different cultural origins. In the case of the hourglass-shaped container of alleged Zulu origin, a successful balance is achieved between the bead-covered body of the gourd and its uncovered, naked neck. The example of possible Northern Nguni origin shows a most intricate beaded wrapping of the gourd. Aside from their use as snuff utensils, both objects were worn as an integral part of a larger ensemble of beadwork and were always viewed and appreciated in conjunction with various other beaded adornments, dress as well as jewelry. Well before the introduction of glass beads by European traders, African communities acquired beads of Indian manufacture from Arab traders (Klopper 2000: 21; see also Kaufmann 1993).

PROVENANCE

Cat. 25. Michael Graham-Stewart, London, — to 1989.
Cat. 26. Peter Adler, London; Jacaranda Tribal, New York.

27 SNUFF CONTAINER

Xhosa people, South Africa
Hide, earth, blood; H. 9.5 cm (3¾ in.)
National Museum of African Art, Smithsonian Institution, Washington, D.C. (Museum purchase, 89-14-15)

This snuff container was made of materials—a combination of hide scrapings, blood, and earth—believed to be distinctive of Xhosa-speaking peoples in the Eastern Cape (Karel Nel, in Phillips 1995: 215). The mixture, modeled over a clay core, was removed when it had hardened into a leathery material. While the clay was still pliable, the artist used a sharp implement to shape the pointed protrusions. Typically, however, such uncanny materials were used to make bull- or cattle-shaped snuff containers, and this example, whose form suggests a gourd, is indeed unusual. Snuff containers like this one were believed to have protective talismanic powers because the substances used to make them were collected from the hides of animals that had been offered to the ancestors.

PROVENANCE

Dr. Werner Muensterberger, New York, c. 1950–80 to 1989.

28, 29, 30 THREE LIDDED VESSELS

Swazi people, Swaziland, or Northern Nguni or Zulu people, South Africa
Wood; H. 53.9 cm (21¼ in.) |
Wood; H. 33.6 cm (13¼ in.) | Wood; H. 58.4 cm (23 in.)
Private collection, courtesy Robert Dowling, San Francisco (cats. 28, 29) | Private collection (cat. 30)

Carved from one piece of wood and decorated with a linear pattern of deeply incised parallel bands, each of these lidded vessels is a true feat of virtuosity on the part of its maker. What Karel Nel (in Bassani et al. 2002: 242) has written with regard to a vessel in the Horstmann Collection can also be applied to the three works illustrated here: "The low relief patterns have an ease and fluency one would associate with the work of clay." Containers wrapped in an integrally carved surrounding structure, as in cat. 30, are extremely rare. Still, because the few known examples of this unusual type of vessel—the majority of which are preserved in public institutions in Europe and South Africa—are stylistically and technically so similar, it has been suggested that they may have been the work of a single workshop, if not artist (Sandra Klopper, in Phillips 1995: 223). Nothing is known with certainty about these works' original function or the meaning of their decoration. However, unlike the terracotta beer pots and the wooden milk pail in this volume (cats. 40–42), none of the surviving lidded wooden containers appears to have held a liquid substance. In fact, given the lack of traces of wear and usage, such vessels may not have been destined for indigenous clients but instead carved for sale to outsiders, most likely Europeans (Nel 2002: 28). It is also possible, however, that these virtuoso works served as display objects for chiefs and kings, who treasured them as expressions of their own elevated status. Yet another explanation is that they were used as storage vessels for snuff and belonged to important individuals who distributed snuff during elaborate festivals organized to honor the ancestors. In some examples, the lid would have functioned as a cup to hand out the snuff.

PROVENANCE

Cat. 28. Vincent Price, Los Angeles; Jacaranda Tribal, New York.
Cat. 29. Sherwin Memel, Los Angeles; Jacaranda Tribal, New York.
Cat. 30. Private collection, United States; Sotheby's (New York), 1990.

PUBLICATIONS

Cat. 30. Sotheby's 1990, lot 195.

31 SPOON

Zulu people, South Africa
Wood; H. 31.1 cm (12¼ in.)
Private collection

Sumptuous embellishment and skillful carving transform many spoons from southern Africa from humble household items into true works of art (Rayda Becker, in Phillips 1995: 220; Karel Nel, in Bassani et al. 2002: 224). This spoon is unusual in its stylized rendering of a full female figure with the typical pointed hairdo, delicate facial features, small breasts, and the carved suggestion of the pubic area. Its deep patina and the subtle erosion of its sensuous contours indicate repeated usage in the daily preparation and/or serving of food—consumption as such is customarily done with the fingers. Nothing is known about the nature of its symbolism, if any, however. The female imagery on a spoon could be related to its ownership and may point to the fact that it was purchased by a husband as part of his *lobola* (bride-price or dowry) and would be returned to his wife's family upon her death. Usually, however, spoons, like other personal objects, were buried with their owners.

PROVENANCE

Ken Karner, Franschhoek, South Africa.

PUBLICATIONS

Brincard 2008, cat. 102.

32, 33 TWO SNUFF SPOONS

Zulu people, South Africa
Bone; H. 15.2 cm (6 in.) | Bone; H. 17.8 cm (7 in.)
The Cleveland Museum of Art, Gift of Dori and Daniel Rootenberg, Jacaranda Tribal, New York 2010.233 and 2010.234

Often, as in these two examples, snuff spoons in bone or ivory are subtly carved to suggest the human and specifically female form with the scoop representing the head. Decorated with engraved designs filled with black pigment, many are true hybrid objects combining a spoon with a long-tined comb or hairpin. As can be seen in engravings and photographs, such spoons were typically worn as ornaments in the hair, thus signaling the social standing of their wearer. Their first use, however, was as a spatula or scoop to bring small quantities of snuff to the nostrils (Nel 2002: 29). Sometimes, the bowls are paired allowing the user to sniff the snuff through both nostrils simultaneously. Interestingly, these two spoons were collected in South Africa by the American missionary Gertrude Hance (1844–1922), a native of Brookdale, Pennsylvania, who from 1870 to 1899 was stationed in what is today known as KwaZulu Natal. Upon her death in Binghamton, New York, some of

the works she acquired in the field were sold at auction in New York. Others, however, including the two spoons illustrated here, remained in her family until 2007.

PROVENANCE

Gertrude Hance, acquired in South Africa, 1870–99; by descent within the Hance family, 1922 to 2007; Jacaranda Tribal, New York, 2007 to 2010.

34, 35 TWO SNUFF SPOONS/COMBS

Northern Nguni people, South Africa
Bone; H. 18.7 cm (7⅜ in.) | Bone;
H. 20 cm (7⅞ in.)
National Museum of African Art, Smithsonian Institution, Washington, D.C. (James Smithson Society, 89-8-67 and 89-8-69)

These two finely decorated objects are a combination of snuff spoon and comb. Made from a rib bone of an ox or cow, the incised designs were blackened with cattle fat and ash. Their long slender tines allow insertion in the hair or even the beard as embellishments. The C-shaped scoop of cat. 35, which seems to be bent rather carved (Nel 2002: 29), would have allowed the user to bring small amounts of snuff to both nostrils at the same time.

PROVENANCE

Michael Graham-Stewart, London, — to 1989.

36, 37,* 38 THREE SPOONS

Zulu people, South Africa
Wood; H. 34.3 cm (13½ in.) | Wood;
H. 40 cm (15¾ in.) | Wood; H. 31.1 cm
(12¼ in.)
Phillips Collection

Like so many other genres of portable art produced in the vast region that is southern Africa, the form of wooden Zulu spoons varies widely, ranging from austere abstraction to exuberant figuration. Often, as in two of the examples here, the conical form at the end of the spoon's handle gives the object a phallic appearance. The importance attached to spoons and other domestic objects was marked by the appropriate behavior surrounding their use. Spoons had to be placed in a particular way around a shared food dish rather than left standing in it (Hooper 1996: 78). When not in use they were stored in protective pouches or covers of woven grass.

PROVENANCE

Colin Sayer, Cape Town; Jacaranda Tribal, New York.

39 BEER SKIMMER

Zulu people, South Africa
Wood; L. 55.2 cm (21¾ in.)
Dede and Oscar Feldman

Embellished with colorful glass beads, the blackened surface of this beer skimmer is decorated with multiple incised renderings of the beloved *amasumpa* (warts or bumps) motif, once reserved for the Zulu royal family. Applied to various object genres, the gridlike design consists of series of shallow raised pyramids. In the Zulu kingdom, where it was first used in the 19th century, the motif was considered to represent wealth in the form of cattle. References to cattle on beer strainers and skimmers and beer vessels invoke the ancestors. Indeed, the husband or son of the senior woman in a household would pour libations of beer to his forefathers on a special platform at the rear of her home. Most often, however, beer skimmers were made from plaited strips of palm fronds or perforated metal (Zaloumis and Difford 2000: 184).

PROVENANCE

Drs. Noble and Jean Endicott, New York; Jacaranda Tribal, New York.

40, 41 TWO VESSELS

Zulu people, South Africa
Terracotta; H. 30.5 cm (12 in.) |
Terracotta; H. 40.6 cm (16 in.)
Bill and Gail Simmons | Private collection

Rimless terracotta vessels like cat. 40, of a type called *ukhamba* and originally covered with a separate lid made of woven grass, were used to serve the locally brewed sorghum- or millet-based beer on ritual and other occasions. During these events, the quantity and quality of the beer offered to participants confirmed social hierarchies. Cat. 41, however, is a type of pot called *uphiso* that is used to transport beer or water. Its spherical form was meant to maximize capacity, while the cylindrical neck helped keep the liquid inside from spilling (Jolles 2008: 408). Such thin-walled terracotta containers were handmade exclusively by women using a coiling technique. Burnishing and a double firing caused their typical black color. Both vessels are decorated with patterns in raised relief that are probably a variant on a motif commonly known as *amasumpa* (Jolles 2001: 310–11). Literally meaning "warts," this design symbolizes a herd of cattle. It is also found on so-called pregnancy aprons made of leather and on headrests and various other types of objects carved in wood

(for example, cats. 39, 42). The motif, which seems to have been invented by sculptors who worked at the Zulu royal court in the 19th century, was associated with kingship. Early photographs show that wives and unmarried Zulu girls beautified their upper bodies and arms with similar designs through permanent scars (Robert Papini, in Philips 1995: 220–21). The reference to cattle on beer vessels, however, evokes the ancestors' guidance and the blessing of their descendants; beer from these vessels is therefore also poured as a libation to one's forefathers. Interestingly, aside from their decorative value, the relief patterns also allow a firm grip on a slippery pot. The shape of many vessels is associated with the female body, and to many the process of brewing beer is comparable to pregnancy.

PROVENANCE

Cat. 40. Peter Pickford, acquired in KwaZulu Natal, 1993; Steven de Combes, Cape Town.
Cat. 41. Roger Orchard, Durban; Jacaranda Tribal, New York.

PUBLICATIONS

Cat. 41. Zaloumis and Difford 2000, 178–79.

42 MILK PAIL

Zulu people, South Africa
Wood; H. 45.7 cm (19¾ in.)
Frank F. Williams

For the pastoralists who used this type of vessel, made and used by a man, cattle signaled wealth and milk was the most important food. Its owner would hold the milk pail between his knees while he milked the cow. In the homestead the milk would be transferred from the male pail to a terracotta vessel, a female type of container made and used exclusively by a woman (Karel Nel, in Bassani et al. 2002: 236). Despite its abstract, nonfigurative shape, the pail's elongated swelling form alludes to a human torso. The geometric decorative designs carved in low relief on the surface accentuate its smooth curves and lustrous patina resulting from many years of daily use and care.

PROVENANCE

Merton Simpson, New York; Drs. Noble and Jean Endicott, New York; Jacaranda Tribal, New York.

43 FOUR-LEGGED VESSEL

Southern Sotho people, Lesotho
Wood; H. 25.4 cm (10 in.)
Private collection

This most original container, with its striking pokerwork surface decoration and four hornlike legs, seems to be one of a kind. The overall design and the type of wood from which it was carved make it closely resemble a ceramic vessel. This impression is heightened by its blackened incised embellishments. Like many other works from southern Africa, this particular vessel is both simple and sumptuous. Its closest relative in the West is perhaps the more elaborate bowl in the collection of Kevin Conru (Nel 2002: 25). Here, too, because of their swelling and tapering form, the loops connecting the bowl to the base suggest cattle horns. Like the Conru bowl, the unusual elevated shape of this vessel and its rich, lustrous patina suggest a ritual purpose.

PROVENANCE

Jonathan Lowen, London; Bowmint Collection, Pretoria.

44 KNOBKERRIE

Zulu people, South Africa
Wood; H. 66 cm (26 in.)
The Cleveland Museum of Art, Gift of Dori and Daniel Rootenberg, Jacaranda Tribal, New York 2010.232

Relatively short sticks or clubs made from hardwoods selected from the local forests or woodlands were traditionally used for hunting and fighting. Often found in early collections but never explicitly made for the tourist market, such objects are customarily called knobkerries. Meaning knob-sticks, the name refers to the characteristic spherical knob of wood or head on top of a cylindrical shaft. The shafts could be elegantly tapered as in the examples illustrated in this publication, but sometimes they were also decorated with carvings or brass and copper wirework. Though often simply plain, the knobs themselves could also be decorated with copper or brass studs or carved in various shapes and forms. This club, with its sliced-off spherical knob, exemplifies a classic style produced by Zulu carvers. Some have read a human head in these seemingly nonfigurative clubs, with the shallow scalloping of the top part of the knob as the stylized representation of a once-fashionable head ornament. The deep glossy patina of this example suggests repeated usage.

PROVENANCE

Merton Simpson, New York, 1992; Marc and Denyse Ginzberg, New York, 1992 to 2005; Jacaranda Tribal, New York, 2005 to 2010.

PUBLICATIONS

Ginzberg 2000, 203.

45 KNOBKERRIE

Zulu people, South Africa
Rhinoceros horn; H. 52.1 cm (20½ in.)
Drs. Noble and Jean Endicott

This elegant knobkerrie of modest size carved out of rhinoceros horn was probably made for a chief as a symbol of status. Like so many forms of nonfigurative art of southern Africa, this club's knob suggests an abstracted human face and hairdo. During the 19th century, rhinoceros horn was sometimes also used for staffs of office. Since animals with long horns were rare, there was a direct correlation between the value of a staff and its length.

PROVENANCE
Merton Simpson, New York, 1993.
PUBLICATIONS
Ginzberg 2000, 200.

46 KNOBKERRIE

Swazi people, Swaziland
Wood; H. 66 cm (26 in.)
The Cleveland Museum of Art,
Leonard C. Hanna Jr. Fund 2010.203

The knob of this sophisticated example is finely carved in the shape of a series of concentric circles with tubular protrusions on either side. Despite its abstract geometric realization, this club too takes the appearance of a human face with bulging eyes. Even though their basic forms were derived from real weapons, many of these precious knobkerries were rarely if ever used as such (Karel Nel, in Bassani et al. 2002: 234). Highly personal objects, they instead functioned as ceremonial display items or regalia, symbolizing the masculinity and prowess of their owner.

PROVENANCE
Drs. Noble and Jean Endicott, New York, — to 2005; Jacaranda Tribal, New York, 2005 to 2010.

47 SNUFF KERRIE

Zulu people, South Africa
Wood; H. 50.8 cm (20 in.)
Private collection

Another example of a hybrid sculpture, like the snuff spoons that also function as hair ornaments and the staffs that incorporate a headrest, this knobkerrie has a snuff container in its knob, complete with a conically shaped stopper. Rather than being used as fighting sticks by warriors in battle, such clubs were probably carried ostentatiously by elite men to denote their status (Nel 2002: 29). In this case, longitudinal grooves carved into the knob suggest an exotic fruit pod.
PROVENANCE
Kevin Conru, Brussels.

48 PRESTIGE STAFF

Zulu people, South Africa
Wood; H. 180.3 cm (71 in.)
Private collection

Many figurative and nonfigurative staffs from southern Africa were made by Tsonga-speaking carvers who supplied them to the Zulu kingdom as part of the tribute they owed Shaka, the famous Zulu king who ruled from 1816 until his assassination on September 24, 1828, and his successors (Sandra Klopper, in Phillips 1995: 209; see also Laband 1996: 18–19). Although some were made for a nonindigenous market and others served as attributes of healers and had a ritual function, most very tall staffs with abstract decorations were most likely owned and used by chiefs. Such staffs show a great regional variation in terms of style and iconography. Examples with geometrically conceived designs were most likely exclusive to high-ranking title holders in the Zulu kingdom. The geometric designs of this staff's finial recall the shape of an axe, the most powerful royal or chiefly symbol in Zulu-speaking communities, but they may actually represent cow horns and evoke ideas of authority and fertility typically associated by southern African herders with cattle (Klopper 2002: 84).
PROVENANCE
Private collection, United Kingdom.

49 PRESTIGE STAFF

Possibly Tsonga people, South Africa
Wood; H. 154.9 cm (61 in.)
Private collection, courtesy Sotheby's, New York

This seemingly unique staff, with a glossy, deep reddish-brown patina, bears a striking carved openwork finial, which may suggest an embracing couple and may allude to the interaction and interrelationship between genders (Heinrich Schweizer, in Sotheby's 2006: 168). The geometric shape may also contain implicit gender references through the subtle integration of male and female genitalia. However, it should be pointed out that some of the motifs represented on chiefs' staffs were not meant to carry or convey any meaning. Instead, they speak to an appreciation of a carver's ability to combine and contrast various shapes and forms.
PROVENANCE
Ralph Nash, London, — to 1962; William Brill, New York, 1962 to 2006; Sotheby's (New York), 2006.
PUBLICATIONS
Robbins and Nooter 1989, fig. 1364; Sotheby's 2006, lot 162.

50 PRESTIGE STAFF

Northern Nguni people, South Africa
Wood; H. 147 cm (58 in.)
Dr. Gary van Wyk and Lisa Brittan,
Axis Gallery, New York

The deep symbolism inherent in staffs of southern Africa is most pronounced in so-called snake or serpent staffs of which this is a prime example. The property of a ritual healer, such a staff would have served as a divining rod. Typically, these serpent staffs were crowned by a spherical knob and decorated with one, two, or even three intertwining coiled snakes along the shaft, often spiraling up the full length of the stick. This kind of staff seems to have been popular among groups in southern Natal (Sandra Klopper, in Phillips 1995: 209). A striking feature of such staffs, as Karel Nel (2002: 31) has pointed out, is that "if one holds the stick and draws one's hand gently down the shaft, the raised spirals on the stick cause it to revolve, making it seem as if the stick takes a life of its own. For the viewer, the sight of the stick revolving seemingly of its own accord is mesmerizing, uncanny." In southern Africa, snakes were considered a sign of the ancestors and seen as ancestral messengers. As a result, they were treated with great respect and never killed. Their representation on staffs of healers, whose main task it was to communicate between the material world and the spirit world, seems therefore also perfectly appropriate.
PROVENANCE
Finch and Co., London, 2004.

51 PRESTIGE STAFF

Tsonga or Zulu people, South Africa
Wood; H. 116.8 cm (46 in.)
The Cleveland Museum of Art, Leonard
C. Hanna Jr. Fund 2010.205

The primary use of long staffs like this example was purely practical; they served as walking companions when their pastoralist owners covered long distances accompanying their cattle in search of new pastures (Nel 2002: 31). The height of this staff, as that of a few others in this publication, however, indicates the elevated status or special function of the man who owned it. Carved from one piece of wood, the spherical knob finial and the geometric designs incorporated into the shaft decoration—consisting of spiraling segments and chain links—demonstrate its maker's superior skills. This virtuosity in turn also reflects the taste and status of its owner. Ultimately, all staffs, whether figurative or nonfigurative, have strong symbolic associations and value. Imbued with ancestral power and presence, they connect the identity of their owners with that of their ancestors and with that of the community to which they belong (Nel 2002: 33).
PROVENANCE
Colette Ghysels, Brussels; Joel Cooner, Dallas, 2005; Jacaranda Tribal, New York, 2005 to 2010.

52, 53 TWO PRESTIGE STAFFS

Tsonga or Zulu people, South Africa
Wood; H. 87.5 cm (34½ in.) |
Wood; H. 92.7 cm (36½ in.)
Jane and Gerald Katcher | Randy Fertel

"Virtuoso," "exuberant," and "extravagant" are some of the words that spring to mind when looking at these two nonfigurative staffs. Their exceptional craftsmanship suggests that they were the property of chiefs or other high officials. Both made out of a single piece of wood, the shaft of one is interrupted by a thick knot, while that of the other is composed of two twisted coils. Most striking is the fact that both staffs play off the natural contrast between the light and dark tones of the hardwood from which they were carved. Their lustrous patinas, which must result from continuous handling over a long period of time, enhance their visual perfection and at once confirm the value they were assigned by their original owners and caretakers.
PROVENANCE
Cat. 52. Alain Guisson, Brussels; Kevin Conru, Brussels.
Cat. 53. Private collection, United Kingdom; Jacaranda Tribal, New York.
PUBLICATIONS
Cat. 52. Conru 2005, 9–10.

54, 55 TWO STAFFS

Probably Tsonga people, Mozambique and South Africa

Wood; H. 109.2 cm (43 in.) |
Wood; H. 120.7 cm (47½ in.)
Private collection | The Cleveland
Museum of Art, Leonard C. Hanna Jr.
Fund 2010.204

Unlike other examples, these two figurative staffs are remarkably complete. Both have been attributed to an itinerant Tsonga artist who would have been active in the Zulu kingdom in the late 19th century in the vicinity of Pietermaritzburg or Durban. Although mother-and-child finials seem to have been his favorite subject, he also created a number of staffs that include images of one or two baboons in their finial decoration. Because of this idiosyncratic iconographic feature, the artist in question —whose identity remains unknown—has been labeled the "Baboon Master." Still, on the basis of stylistic differences between assorted staffs presenting variations on the themes of mother-and-child and baboon, it has been suggested that some would be the work of apprentices in the Baboon Master's workshop or of his son (Klopper 1991: 93). The maternity staff finial shows a woman wearing a peaked hairstyle typical of married Zulu women in late 19th- and early 20th-century Natal. The woman's elegance is counterbalanced by the endearing way her naked child grasps her belly with his arms and legs. Cat. 55 is perhaps the most refined surviving example representing a baboon standing on the busts of two men wearing the characteristic head ornament commonly referred to as a head-ring called *isicoco* (Sandra Klopper, in Sotheby's 2005: 106). Consisting of a fiber or sinew circle into which the wearer's own hair was woven and covered with a mixture of gum, charcoal, and oil, it signified maturity and marriage. Despite the prevalence of baboon imagery in the staffs of this master carver and his workshop, the animal carried no particular religious or social meaning in Zulu symbolism. Some have therefore suggested that staffs with this striking subject matter were carved for sale to tourists in colonial Natal.

PROVENANCE
Cat. 54. Private collection, United Kingdom.
Cat. 55. Private collection, United Kingdom; Sotheby's (New York), 2005; Jacaranda Tribal, New York, 2005 to 2010.

PUBLICATIONS
Cat. 55. Sotheby's 2005, frontispiece and lot 161.

56, 57 TWO STAFF FINIALS

Probably Tsonga people, Mozambique and South Africa

Wood; H. 30 cm (11⅞ in.) |
Wood; H. 30.8 cm (12 in.)
Jane and Gerald Katcher | Private collection

These two figures were obviously removed from the sticks they once surmounted, a practice driven in part by a desire to transform them into small sculptures in order to meet European ideas about "high art" and thus make the works fit better in Western collections (Nel 2002: 32). It is also possible that the figures were cut from their sticks in order to facilitate their transport to Europe. Based on their stylistic affinities, scholars have suggested that the two staff finials illustrated here as well as some other works were made by the same hand in the late 19th or early 20th century, most likely a Tsonga immigrant from Mozambique who established himself in Natal looking for work (Sandra Klopper, in Phillips 1995: 225). The figures, whose gender cannot be determined, have been linked to figure pairs and figurative walking sticks that were made for a foreign market. However, among the unusual formal features setting these staff finials apart from more typical tourist pieces is the absence of pokerwork markings on the surface to indicate certain facial traits. The artist held responsible for the creation of the figures has been named the "Master of the Small Hands" on the basis of the peculiar way he rendered this anatomical feature (Klopper 2001). Like other sculptures in the same personal style, these finials were carved in the prestigious reddish wood for which local artists seem to have had a strong preference.

PROVENANCE
Cat. 56. K. John Hewett, London/Bog Farm; private collection, United Kingdom, — to 1999; Sotheby's (New York), 1999.
Cat. 57. K. John Hewett, London/Bog Farm; Merton Simpson, New York; Philip Sanfield, Detroit, — to 1990; Sotheby's (New York), 1990; Baudouin de Grunne, Brussels.

PUBLICATIONS
Cat. 56. Berjonneau and Sonnery 1987, fig. 242; Phillips 1995, cat. 3.42c; Sotheby's 1999, lot 235; De Grunne 2001, cat. 89.
Cat. 57. *Detroit Collects* 1977, cat. 200; Sotheby's 1990, lot 192; Guimiot and de Grunne 1995, cat. 48; Phillips 1995, cat. 3.42a; De Grunne 2001, cat. 91.

58 DANCE STAFF

Zulu or Tsonga-Shangaan people,
South Africa
Wood, brass, copper; H. 86.4 cm (34 in.)
Phillips Collection

Among the Zulu and various other Nguni-speaking groups, including the Tsonga-Shangaan (a cluster of Nguni-influenced peoples), carefully carved dance staffs, often embellished with intricate woven-wire decoration, were among the many accouterments of the *ingoma* dance costume. Closely related to a 19th-century style of Nguni military attire, this elaborate costume consisted of layers of animal skins, beads, and feathers. In the context of warfare this accumulation of materials not only served as a protective armor, it was also meant "to impress, frighten, confuse, and magically charm an enemy into impotency" (Michael Conner, in Greub 1988: 104). The application of wire braiding or, rather, weaving on highly visible objects of status, which sometimes integrate up to three different metals (brass, copper, and even iron), is typically done by men. Interestingly, the three geometric shapes decorating this staff's finial suggest a schematic representation of a female figure with head, breasts, and buttocks and legs. Among the Jere-Ngoni (an isolated Nguni group in Malawi) staffs used in the traditional ingoma dance were similarly carved with abstract anthropomorphic forms. In times past, such staffs would have been treated like feminine dance partners; the human-shaped protrusions facing the dancer intended to infuse grace and vigor in his performance.

PROVENANCE
Private collection, United Kingdom; Jacaranda Tribal, New York.

59 DANCE STAFF

Southern Sotho people, Lesotho
Wood, glass beads; H. 74.3 cm (29¼ in.)
Private collection

With a section of its shaft wrapped in delicate beadwork and a geometrically decorated knob finial with four horizontal barrel-like flanges, this short wooden stick most likely served as a dance staff. Its Southern Sotho origin can be partly deduced from the green and pink colors typical of much of their beadwork.

PROVENANCE
Peter Adler, London; Bowmint Collection, Pretoria.

60* AXE

Ndebele (Matabele) or Shona people,
Zimbabwe
Wood, wirework, iron; H. 40.1 cm (16 in.)
Private collection

Like knives and knobkerries, axes are often elaborately decorated with wirework, sometimes, as in this example, combining three different "weaving" techniques.

PROVENANCE
Antiquités Guérin, Paris; Jacaranda Tribal, New York.

61, 62 TWO AXES

Probably Tsonga people, South Africa |
Shona people, Zimbabwe, or Venda people, South Africa and Zimbabwe
Wood, iron, glass seed beads;
H. 64 cm (25 in.) | Wood, iron; H. 73.3 cm (28⅞ in.)
Dr. Gary van Wyk and Lisa Brittan, Axis Gallery, New York | Private collection

Judging from written sources and engravings, axes similar to the ones illustrated here were already observed in Zimbabwe in the mid-19th century (Dewey and Mvenge 1997: 205–6). Similar to the fate of numerous headrests, axes and knives were preserved as heirlooms and transmitted from one generation to the next. In addition to their role as indicators of status, they also carried ancestral symbolism. Rather than a battle weapon, cat. 61, with its unique iconographical scheme, was most likely used as a ritual object during spirit possessions to embody female ancestral power. The spiked blade is specifically related to battle among the Tsonga as well as the Venda and Shona. Through its imagery the axe proclaims female authority over war and thus female political power (Gary van Wyk, e-mail communication, 16 October 2009). Cat. 62 is remarkable for its carved embellishments. Though mainly geometric and abstract, it is possible to read figurative elements in its elegant design as well. Thus, the axe handle seems to be topped by a schematized representation of a vessel of some kind, while the two conical projections along its shaft are obviously references to female breasts. While it was undoubtedly owned and used exclusively by a man, this axe, like many other ritual and ceremonial weapons in southern Africa, was symbolically perceived to be of female gender (William Dewey, in Dewey and De Palmenaer 1997: 281).

PROVENANCE
Cat. 61. Norman Hurst, Cambridge, Mass., 1990 to 2000.
Cat. 62. Marc and Denyse Ginzberg, New York.

PUBLICATIONS
Cat. 61. Hurst 1997, frontispiece and p. 45.
Cat. 62. *Perspectives* 1987, 171; Robbins and Nooter 1989, fig. 1372.

63 KNIFE WITH SHEATH

Shona people, Zimbabwe
Wood, metal, sinew; H. 52.1 cm (20½ in.)
Private collection

Rather than tools with a practical purpose, large Shona knives like this example, with its elaborately carved wooden handle and sheath and double-edged blade, have important ritual and ceremonial connotations. Part of the paraphernalia of healers-diviners and spirit mediums, knives are used to deliver messages to the ancestors. The relief patterns gracing the handles and sheaths, however, are said to be purely decorative, simply meant to enhance the works' beauty (Dewey and Mvenge 1997: 202–4).

PROVENANCE
Axis Gallery, New York; Jacaranda Tribal, New York.

64 KNIFE WITH SHEATH

Tswana (Western Sotho) people,
South Africa and Botswana
Bone, sinew, wood, metal;
H. 23.7 cm (9⅜ in.)
Private collection

Knives like this example, carved out of bone with a figurative handle and a sheath in the same material, are rare. Whether the geometric decorative designs have any meaning is not known, and the exact identity of the animal surmounting the handle remains elusive, too. In the 19th century knives of this type would have been worn around the neck suspended from a leather string. Rather than serving as a weapon, the object would have been used as a sort of pocket knife.

PROVENANCE
Kevin Conru, Brussels; Bowmint Collection, Pretoria.

65, 66* TWO BRIDAL TRAINS

Ndebele people, South Africa
Glass beads, cotton thread; H. 167.6 cm
(66 in.) | H. 198.1 cm (78 in.)
Suzanne Priebatsch and Natalie Knight

These bridal trains were once part of the elaborate costume worn by Ndebele brides. One of many ways to wear them was hanging from the head or neck with the help of a headband or loop. They could also be attached to the back of a sheepskin cloak. Sometimes a woman would wear two such trains at once, one in the front, the other at the back (Nessa Leibhammer, in Phillips

1995: 218–19). Interestingly, *nyoka,* the local name for such beaded trains, means "snake." However, rather than bearing any reference to fertility or the ancestors, the name derives from the fact that during the bride's dance the train touched the ground and moved in ways recalling the reptile. Not only do such beaded trains vary greatly in size and length, they also show considerable diversity in the designs and colors of their surface decoration. Always made by female artists, examples from before 1940 are predominantly white and decorated with a limited number of small, largely geometric designs in blue and red only. In more recent times, these beaded trains, like other types of beadwork, have become more colorful and more elaborately decorated, sometimes with complex designs including the representation of figurative motifs and even numbers and letters.

PROVENANCE
Suzanne Priebatsch, acquired in the Transvaal, South Africa, c. 1975.

67 NECKLACE

Northern Nguni people, South Africa
Glass beads, bone, sinew; L. 38.1 cm (15 in.)
The Cleveland Museum of Art, Gift of Dori and Daniel Rootenberg in memory of Estelle Rosenberg 2010.231

Amazipho is the name given by the Northern Nguni and other Zulu-speaking peoples to necklaces made from pieces of bone carved in the shape of a lion claw. When wild game was still plentiful in the region, real animal claws would have been used instead to punctuate beaded prestige necklaces. Lion-claw necklaces were the exclusive property of Nguni royalty, while the bone imitations were also owned and worn by high-ranking individuals of lesser status. Exceptionally large red glass beads like the ones that alternate with the carved claws in this example were also reserved for the Nguni elite in the period before the destruction of the Zulu kingdom in 1879. However, while it is not known why red beads were particularly favored in the 19th-century Zulu kingdom, it may have been related to the ritual use of red ocher. Of course, because it is the color of (menstrual) blood, red is also often associated with fertility (Klopper 2000: 29). As elsewhere in Africa, lions, leopards, and other ferocious beasts were symbolically associated with the power and supremacy of leaders and nobles.

PROVENANCE
Nelly Van den Abbeele, Brussels, — to 2003; Christie's (Paris), 2003; Axis Gallery,

New York, 2003 to 2005; Dori and Daniel Rootenberg, New York, 2005 to 2010.

PUBLICATIONS
Christie's 2003, lot 121; Pemberton 2008, vii (detail) and cat. 127.

68,* 69* APRON AND BELT

Southern Sotho people, Lesotho |
Southern Sotho, Lesotho, or Northern Nguni people, South Africa
Glass seed beads, sinew, twine, seeds;
H. 14 cm (5½ in.) | Grass core, cotton cloth and thread, glass seed beads, sinew, twine; L. 106 cm (42 in.)
Dr. Gary van Wyk and Lisa Brittan, Axis Gallery, New York

Although this apron panel and waistband match stylistically and their colors and patterns confirm their Southern Sotho origin, they were not field-collected at the same time and do not constitute a true pair. Both works show a playful irregularity in their design. The belt comprising several beaded ropes is a type of beadwork that can be found among different groups in southern Africa. It consists of bead rolls made of single strands of beads wrapped around a cloth or fiber core. In this case five such rolls have been stitched together to form a wider belt or waistband. Like brass buttons, which are sometimes integrated into beadwork, especially among the Northern Nguni people, glass beads were mainly a European import and scarce, at least in their early history until the 19th century. Aside from occasional earlier imports from China, India, and the Near East, glass beads made in Venice and Bohemia were introduced by the Portuguese and English from the 16th century onward. Because beads were expensive and even used as currency throughout the 19th century, they also signified wealth and status. Wearing beaded garments and jewelry was therefore also a way to express thanks to the ancestors who were believed to be the source of one's fortune. Glass beads in beadwork, along with shell and brass buttons, were probably perceived as "possessed of divine shine" (Van Wyk 2003: 19). The Xhosa in the Eastern Cape initially believed that "glass beads washed up on the shore came from ancestors in the sea" (ibid.). And here, at least until the early 1800s, glass beads and mother-of-pearl buttons were almost as valuable as iron and even cattle.

PROVENANCE
Cat. 68. Carol Kaufmann, Cape Town, — to 2000; Avril von Hirschberg, Cape Town, 2000.

Cat. 69. Nelly Van den Abbeele, Brussels, — to 2003; Christie's (Paris), 2003.

PUBLICATIONS
Cat. 69. Christie's 2003, lot 122.

70* APRON

Southern Sotho people, Lesotho,
or Northern Nguni people, South Africa
Glass seed beads, cotton thread, sinew;
W. 26 cm (10¼ in.)
Private collection

In its colors and design this finely made woman's apron combines stylistic features characteristic of Southern Sotho beadwork (the distinctive pattern is also common in their mural designs), with traits considered proper to the Northern Nguni. As can be seen in field photographs of the early 20th century, such an apron would have been worn combined or even layered with other elements of beadwork in dress and adornment. Gary van Wyk (2003: 12) has written that the abstract patterns of the beadwork of Xhosa and Zulu speakers conveyed meaning and that their beadwork traditions were semiotic systems and dynamic like language itself. Without being rigid or fixed, beadwork signaled a sense of belonging to a people and/or a place. Conveying social identities, beadwork not only signaled age and status, it also denoted gender-related responsibilities and influence. But beadwork was also and continues to be a means of self-expression, reflecting the styles of its maker and its wearer. Further, beadwork was spiritual art in that it connected the living to their ancestors. The sacred power of beads is also expressed in the fact that people danced for the spirits "dressed in beads that reflect and refract the light" (Van Wyk 2003: 33).

PROVENANCE
Bowmint Collection, Pretoria.

71 NECK ORNAMENT

Northern Nguni people, South Africa
Glass beads, sinew, brass buttons;
L. 68.6 cm (27 in.)
The Cleveland Museum of Art, Leonard C. Hanna Jr. Fund 2010.207

While buying beads was not encouraged in the Zulu kingdom until the mid-19th century, in the Natal chiefdoms beads were actively traded with white settlers in exchange for cattle and other indigenous goods. Design features that identify this neckpiece with panel as Northern Nguni include the zigzag pattern and the fringe

of beads. Typically, such an ornament would have been worn by a woman in conjunction with other beadwork—including a headband, waistband, apron, and anklets using complementary color schemes. In addition to making her own beadwork, however, a woman would also produce her husband's beadwork and, before marriage, the beadwork worn by the young man courting her. Men's beaded garments were usually much less elaborate than those of women.

PROVENANCE
Private collection, United Kingdom, — to 2005; Jacaranda Tribal, New York, 2005 to 2010.

PUBLICATIONS
Pemberton 2008, cat. 101.

72 APRON

Southern Nguni people, South Africa
Leather, glass beads, sinew; H. 35.6 cm (14 in.)
The Cleveland Museum of Art, Leonard C. Hanna Jr. Fund 2010.206

Said to have been worn by young female initiates until the mid-1800s (Kevin Conru, in Klopper and Nel 2002: 194, pl. 34; Conru 2005: 16), this rare type of swallow-tail-shaped apron is distinguished by its austere decorative pattern of mostly black beads on a background of white beads. The figurative elements in its embellishment set this example apart from the few related pieces that have survived. Indeed, the black beads are applied in such a way on the upper portion that they can be read as a human face, with two blue beads as pupils, or even as a full figure. In fact, the overall form of the apron can be viewed as representing the lower torso and legs of a woman with a neatly marked pubic area.

PROVENANCE
Maurice Joy, London; Kevin Conru, Brussels, — to 2006; Jacaranda Tribal, New York, 2006 to 2010.

PUBLICATIONS
Conru 2005, 17 and back cover; Pemberton 2008, cat. 101.

73 PENDANT DOLL

Xhosa people, South Africa
Gourd, glass seed beads, mother-of-pearl buttons, cotton thread; H. 11.5 cm (4½ in.)
Dr. Gary van Wyk and Lisa Brittan, Axis Gallery, New York

Made out of an hourglass-shaped gourd and entirely covered with glass beads, this

"doll" is a variant on the so-called child figure. According to some scholars, gourds were used for the earliest fertility dolls (Nel and Leibhammer 1998: 151). A gourd's womb shape and the fact that it was filled with seeds symbolize fertility. Just one part of attire consisting of many other forms of beaded wear and accessories, the strap allowed hanging the fertility figure over the shoulder or around the neck. The Bohemian and Venetian beads used in Xhosa dress, jewelry, and other works were hard to find before the arrival of British settlers in 1820. About 20 distinctive styles of Xhosa beadwork have been identified and related to geography and ethnic affiliation (Van Wyk 2003: 16). The pink and blue beading of this pendant doll is strikingly similar to the double-paneled vest attributed to the Mfengu people in this publication (cat. 74). The playful decorative use of mother-of-pearl buttons, which the figure also shares with the vest, is typical of western Xhosa groups, such as the Mfengu. Until about 50 years ago beads were strung on sinew from the shoulder area of an ox or goat, but using cotton has become more common. The decline of beadwork in Xhosa society is directly tied to the impact of Christianity. Because wearing and using beads was seen as a manifestation of "pagan" culture, Xhosa people who converted to Christianity "would burn their beadwork to symbolize the break with the past" (Long 2001: 117; see also Proctor and Klopper 1993: 58). However, traditionally, beadwork was also buried with its owner or destroyed and the beads scattered around the home. The woman who collected this doll in South Africa, German-born American Grete Mannheim (1909–1986), operated a photography studio in Johannesburg from 1936 until she immigrated to the United States in 1949. She gained some fame as an author of children's books, which she illustrated with her own photographs.

PROVENANCE
Grete Mannheim, acquired in South Africa, 1936–49; by descent within the Mannheim family, 1986 to 2007.

74 VEST

Mfengu people, South Africa
Glass beads, buttons, cotton thread; H. 59.7 cm (23½ in.)
Private collection

Old Mfengu beadwork is admired for the delicacy of its workmanship and a predilection for pink and blue beads organized in simple geometric patterns. Decorative rows

of mother-of-pearl buttons are another distinct feature. This double-paneled vest could have been worn by a man or a woman. Although a stunning object in itself, its visual impact would have been even greater in its original setting, complemented by other beaded garments and accessories including a headband, earrings, necklaces, and armbands and anklets. Moreover, as Joan Broster (1976: 33) writes with regard to a dance performance among the Tembu in the Eastern Cape region: "Words and photographs cannot adequately describe the brilliance of the beads, the clarity of the colours, or their sparkling effect on the dark skin of the wearer. The beads and movements of the dance produce a vibrant spectacle." Here, as in various other parts of southeastern Africa, beadwork played an important role in courtship relations and dowry payments, and many of the beadwork items were offered by brides and their families to their future husbands (Klopper 2000: 39; see also Hooper 1993: 80).

PROVENANCE
Maureen Schuil, Johannesburg.

PUBLICATIONS
Pemberton 2008, cat. 115.

75 DOLL

Ndebele people, South Africa
Glass beads, straw, cotton thread, sinew; H. 20.3 cm (8 in.)
Suzanne Priebatsch

It is no coincidence that, among the Ndebele, fertility figures like the one illustrated here have a conical shape. As Karel Nel (in Bassani et al. 2002: 232) has written, for Ndebele women the cone shape expresses a female body ideal. The ceremonial beaded blanket contributes to this form as well as the *izigolwane* (beaded neck, leg, and body rings) a woman wears to thicken her limbs (see also Knight and Priebatsch 1983: 18). Ndebele fertility figures would have developed from tassel-like pendants worn by pubescent girls. During the girl's initiation the pendant was covered by a sheath of beads as a core over which narrow beaded hoops were slipped. The transformation from the pendant into a conical figure mirrored the young woman's transition into adulthood. Accessories decorating these figures faithfully imitate Ndebele dress of either married or unmarried women. Although commonly called dolls, they are not children's playthings even though they are manipulated in a manner similar to the way mothers care for their children. Figures that are predominantly

white with minimal and subtle color accents would be among the oldest examples of the genre. However, the rendering of letters on this figure's beaded breast panels—including an inverted K—suggests a "modern" variation on the purely geometric designs gracing earlier beadwork.

PROVENANCE
Suzanne Priebatsch, acquired in the Transvaal, South Africa, c. 1975.

PUBLICATIONS
Pemberton 2008, cat. 145.

76 PENDANT DOLL

Southern Sotho people, Lesotho
Glass beads, mother-of-pearl button, sinew; H. 39.1 cm (15½ in.)
Private collection

This doll was hung around the neck with the help of the long beaded strap attached to it. Karel Nel's captivating description of a Swazi "child figure" in the Horstmann Collection could to some extent be applied to the work illustrated here: "Animated by the wearer's movements, these child-figures, with their distinct lack of volumetric form, assume an unearthly, light and fluid presence, permeating space with their delicacy of substance" (in Bassani et al. 2002: 240). Among different peoples such pendants were given by female admirers to young men who would wear them on their bodies or hang them in their houses to signal their popularity. Research has suggested that the initial tassel-like shape of the pendant figures underwent a series of transformations through which a beaded tassel was progressively encased in a filigree skirt (Nel and Leibhammer 1998: 153). This transformation would parallel the changes in status of a young woman through puberty and marriage whereby the increased rigidity and mass of the pendant figure reflected the woman's childbearing capacity and her role as a spouse. Mother-of-pearl buttons have the same value for the peoples of southern Africa as glass beads. Both indicate wealth and prestige, and both were associated with the ancestors. Among the Xhosa, raiders attempted to steal the mother-of-pearl buttons from the shirts of English settlers, even harassing young cowherds (Tyrrell 1968: 175; Van Wyk 2003: 19). The color scheme and style features of this pendant doll seem to point to a 19th-century date of manufacture. The use of sinew to string the beads may confirm this supposition.

PROVENANCE
Jonathan Lowen, London; Bowmint Collection, Pretoria.

77 DOLL

Southern Sotho people, Lesotho
Gourd, glass beads, hair; H. 11.4 cm (4½ in.)
Blanche and Charles Derby

In present-day Lesotho, fertility dolls, of which this is most probably a 19th-century example, are believed to have originated with Southern Sotho women, after which the use of such objects spread to neighboring peoples (Wood 1998: 49). However, during research conducted in 1988 and 1994, Gary van Wyk discovered that women initiates in recent times carried Barbie dolls at their public graduation ceremonies. One of the first Europeans to encounter such dolls was the French missionary Eugène Casalis, who lived among the Southern Sotho from 1833 to 1856 (Casalis 1861: 251; see also Van Wyk 1998: 53–55). These dolls were used to promote fertility or, more typically, to cure barrenness. Whether the same doll was used for both purposes or whether each constituted a formally different type is not clear. The first type of fertility dolls were sometimes also called "bride dolls" because they "were used in the past by South[ern] Sotho women during wedding ceremonies to demonstrate to their future husbands their desire to bear children" (Wood 1998: 35). The second type was often prescribed by healers. Among the several reasons recognized as causing infertility were "physical abnormalities," promiscuity, and sorcery (Wood 1998: 37). The dolls were cared for as if they were real children and, after they had served their purpose, were either destroyed or left at sacred sites as offerings to the spirits. Although all fertility dolls represent the desire to bear children, rather than representing children, they take the form of adult women capable of procreation. The female gender of the images can usually be determined on the basis of the beaded dress or ornaments. Real human hair adds to the realism of this particular doll.

PROVENANCE
Paul Rabut, Westport, Conn.

78 DOLL

Southern Sotho people, Lesotho
Wood, glass beads, sinew, metal;
H. 25.4 cm (10 in.)
The Cleveland Museum of Art, Leonard C. Hanna Jr. Fund 2010.208

This stylized representation of a human body can be identified as stemming from the Southern Sotho on the basis of the abstract geometric patterns of its beaded designs, as well as the typical, often bold color sequences. Constructed around a wooden core carved by a man, a woman was responsible for wrapping the core in cloth and the intricate beading. Fertility figures like this example were used during the initiation ceremonies of pubescent girls. Integrating talismanic materials in their fabrication, the figures were meant to guarantee fertility and prevent or cure barrenness. Expressing the desire to bear children, the figures are sometimes also called child figures—rather than dolls—because a young bride would care for them as she would for her future children, carrying them on her back and sleeping with them until her first child was born, who would be named after the doll.

PROVENANCE
Jonathan Lowen, London; Bowmint Collection, Pretoria, — to 2009; Jacaranda Tribal, New York, 2009 to 2010.

WORKS CITED

Africa 1996
Africa: The Art of a Continent. 100 Works of Power and Beauty. Exh. cat., Solomon R. Guggenheim Museum. New York: Solomon R. Guggenheim Foundation, 1996.

Albacete 1984
Albacete, M. J. Exhibition review of "African Elegance: The Traditional Art of Southern Africa." *African Arts* 17, 3 (1984): 82–83.

Art and Ambiguity 1991
Art and Ambiguity: Perspectives on the Brenthurst Collection of Southern African Art. Exh. cat. Johannesburg: Johannesburg Art Gallery/Johannesburg City Council, 1991.

Bassani et al. 2002
Bassani, Ezio, Michael Bockemühl, and Patrick McNaughton. *The Power of Form: African Art from the Horstmann Collection*. Milan: Skira, 2002.

Becker 1991
Becker, Rayda. "Headrests: Tsonga Types and Variations," 58–76. In *Art and Ambiguity* 1991.

Becker 2002
———. "Le nom, le style et la région. Quelques réflexions sur les liens entre Tsonga et Nguni," 161–65. In Joubert and Valentin 2002.

Bedford 1993
Bedford, Emma, ed. *Ezakwantu: Beadwork from the Eastern Cape*. Exh. cat. Cape Town: South African National Gallery, 1993.

Berjonneau and Sonnery 1987
Berjonneau, Gérald, and Jean-Louis Sonnery, eds. *Rediscovered Masterpieces of African Art*. Boulogne: Art 135, 1987.

Beumers 1996
Beumers, Erna, ed. *Africa Meets Africa: The Collection of the Museum of Ethnology Rotterdam*. Exh. cat. Rotterdam: Museum of Ethnology, 1996.

Brincard 2008
Brincard, Marie-Thérèse. "Catalogue." In *Constellations: Studies in African Art*, 1: 15–23. Purchase: Neuberger Museum of Art, Purchase College, State University of New York, 2008.

Broster 1976
Broster, Joan A. *The Tembu: Their Beadwork, Songs, and Dances*. Cape Town: Purnell and Sons, 1976.

Casalis 1861
Casalis, Eugène. *The Basutos; or, Twenty-Three Years in South Africa*. London: James Nisbet, 1861.

Christie's 2003
Christie's. *Arts d'Afrique. Collection de Madame Van den Abbeele*. Paris, June 12, 2003.

Christie's 2006
———. *Art Africain et Océanien*. Paris, June 20, 2006.

Conner and Pelrine 1983
Conner, Michael W., and Diane Pelrine. *The Geometric Vision: Arts of the Zulu*. Exh. cat., Stewart Center Gallery. West Lafayette, Ind.: Purdue University Galleries, Department of Creative Arts, 1983.

Conru 2005
Conru, Kevin. *Southeast African and Oceanic Art*. Brussels: Kevin Conru, 2005.

Davison 1991
Davison, Patricia. "Ambiguity, Style and Meaning," 12–18. In *Art and Ambiguity* 1991.

Davison 1995
———. "Southern Africa," 179–85. In Phillips 1995.

Davison 2002
———. "Les arts africains traditionnels dans l'Afrique du Sud post-apartheid," 17–20. In Joubert and Valentin 2002.

De Grunne 2001
De Grunne, Bernard, ed. *Mains de maîtres. À la découverte des sculpteurs d'Afrique*. Exh. cat., Espace Culturel BBL. Brussels: BBL, 2001.

Dell 1998
Dell, Elizabeth, ed. *Evocations of the Child: Fertility Figures of the Southern African Region*. Exh. cat. Johannesburg: Johannesburg Art Gallery; Cape Town: Human & Rousseau, 1998.

De Smet 1998
De Smet, Peter A. G. M. "Traditional Pharmacology and Medicine in Africa: Ethnopharmacological Themes in Sub-Saharan Art Objects and Utensils." *Journal of Ethnopharmacology* 63 (1998): 1–179.

Detroit Collects 1977
Detroit Collects African Art. Exh. cat. Detroit: Detroit Institute of Arts, 1977.

Dewey 1993
Dewey, William J. "Declarations of Status and Conduits to the Spirits: A Case Study of Shona Headrests," 98–133. In William J. Dewey, *Sleeping Beauties: The Jerome L. Joss Collection of African Headrests at UCLA*. Exh cat., Fowler Museum of Cultural History. Los Angeles: University of California, 1993.

Dewey and De Palmenaer 1997
Dewey, William J., and Els De Palmenaer, eds. *Zimbabwe: stenen getuigenissen, heden en verleden*. Exh. cat. Tervuren, Belgium: Koninklijk Museum voor Midden-Afrika, 1997.

Dewey and Mvenge 1997
Dewey, William J., and George T. Mvenge. "De kunst van de Shona: gebruiksvoorwerpen of rituele meesterwerken," 193–214. In Dewey and De Palmenaer 1997.

Eisenhofer 2001
Eisenhofer, Stefan, ed. *Tracing the Rainbow: Art and Life in Southern Africa*. Exh. cat., Schlossmuseum Linz am Oberösterreichischen Landesmuseum. Stuttgart: Arnoldsche, 2001.

Gardiner 1836
Gardiner, Allen F. *Narrative of a Journey to the Zoolu Country, in South Africa*. London: William Crofts, 1836.

Garlake 2002
Garlake, Peter. *Early Art and Architecture of Africa*. Oxford/New York: Oxford University Press, 2002.

Ginzberg 2000
Ginzberg, Marc. *African Forms*. Milan: Skira, 2000.

Gowlett 2003
Gowlett, Derek. "Zone S," 609–38. In Derek Nurse and Gérard Philippson, eds., *The Bantu Languages*. London/New York: Routledge, 2003.

Greub 1988
Greub, Suzanne, ed. *Expressions of Belief: Masterpieces of African, Oceanic, and Indonesian Art from the Museum voor Volkenkunde, Rotterdam*. Exh. cat., Museum of Fine Arts, Houston. New York: Rizzoli, 1988.

Guimiot and de Grunne 1995
Guimiot, Philippe, and Bernard de Grunne. *Regard sur une collection*. Brussels: Philippe Guimiot, 1995.

Hooper 1993
Hooper, Lindsay. "The Social Life of Beads: Expressive Uses of Beadwork in the Eastern Cape," 79–82. In Bedford 1993.

Hooper 1996
———. "Domestic Arts: Carved Wooden Objects in the Home," 73–79. In Wood 1996.

Hooper 2002
———. "Précieux, intimes et publics. Les objets personnels de la vie quotidienne," 105–9. In Joubert and Valentin 2002.

Hurst 1997
Hurst, Norman. *Ngola: The Weapon as Authority, Identity, and Ritual Object in Sub-Saharan Africa*. Exh. cat. Cambridge, Mass.: Hurst Gallery, 1997.

Jolles 2001
Jolles, Frank. "Zulu Beer Vessels," 306–19. In Eisenhofer 2001.

Jolles 2008
———. "Zulu Pottery Styles." In Floriane Morin and Boris Wastiau, eds., *African Terra Cottas: A Millenary Heritage*, 400–419. Geneva: Musée Barbier-Mueller; Paris: Somogy, 2008.

Joubert and Valentin 2002
Joubert, Hélène, and Manuel Valentin, eds. *Ubuntu. Arts et cultures d'Afrique du Sud.* Exh. cat., Musée National des Arts d'Afrique et d'Océanie. Paris: Réunion des Musées Nationaux, 2002.

Kautmann 1993
Kaufmann, Carol. "The Bead Rush: Development of the Nineteenth-century Bead Trade from Cape Town to King William's Town," 47–54. In Bedford 1993.

Klopper 1991
Klopper, Sandra. "'Zulu' Headrests and Figurative Carvings: The Brenthurst Collection and the Art of South-East Africa," 80–98. In *Art and Ambiguity* 1991.

Klopper 1998
——. *The Zulu Kingdom.* New York: Rosen Publishing Group, 1998.

Klopper 2000
——. "From Adornment to Artefact to Art: Historical Perspectives on South-East African Beadwork," 9–43. In Michael Stevenson and Michael Graham-Stewart, eds., *South-East African Beadwork 1850–1910.* Vlaeberg, South Africa: Fernwood Press, 2000.

Klopper 2001
——. "Le Maître des petites mains: la redé-couverte d'un artiste du sud-est de l'Afrique," 248–55. In De Grunne 2001.

Klopper 2002
——. "Sculptures et perlages traditionnels dans le sud-est de l'Afrique," 83–91. In Joubert and Valentin 2002.

Klopper 2004
——. "South Africa's Culture of Collecting: The Unofficial History." *African Arts* 37, 4 (2004): 18–25, 93–94.

Klopper and Nel 2002
Klopper, Sandra, and Karel Nel. *The Art of Southeast Africa from the Conru Collection.* Milan: 5 Continents, 2002.

Klopper, Nettleton, and Pethica 2007
Klopper, Sandra, Anitra Nettleton, and Terence Pethica. *The Art of Southern Africa:*

The Terence Pethica Collection. Milan: 5 Continents, 2007.

Knight and Priebatsch 1983
Knight, Natalie, and Suzanne Priebatsch. *Ndebele Images.* Johannesburg: Natalie Knight Productions, 1983.

Laband 1996
Laband, John. "The Land of the Zulu Kings," 17–23. In Wood 1996.

Leibhammer 2007
Leibhammer, Nessa, ed. *Dungamanzi/ Stirring Waters: Tsonga and Shangaan Art from Southern Africa.* Exh. cat. Johannesburg: Wits University Press, Johannesburg Art Gallery, 2007.

Levinsohn 1979
Levinsohn, Rhoda. *Basketry: A Renaissance in Southern Africa.* Cleveland: Protea Press, 1979.

Levinsohn 1983
——. *African Elegance: The Traditional Art of Southern Africa.* Exh. brochure. Canton, Ohio: Canton Art Institute, 1983.

Levinsohn 1984
——. *Art and Craft of Southern Africa: Treasures in Transition.* Johannesburg/ Cleveland: Delta Books, 1984.

Levy 1992
Levy, Diane. *The Horstmann Collection of Southern African Art.* Exh. cat. Johannesburg: Johannesburg Art Gallery/Johannesburg City Council, 1992.

Lewis-Williams 1983
Lewis-Williams, J. David. *The Rock Art of Southern Africa.* Cambridge: Cambridge University Press, 1983.

Lewis-Williams 2002
——. "Image des San et art san. Une dialectique potentiellement créatrice en Afrique australe," 34–41. In Joubert and Valentin 2002.

Long 2001
Long, Stephen. "Xhosa Beadwork," 116–17. In Eisenhofer 2001.

Mayr 1907
Mayr, Franz. "The Zulu Kafirs of Natal." *Anthropos* 2 (1907): 392–99, 633–45.

Mertens and Broster 1973
Mertens, Alice, and Joan Broster. *African Elegance.* Cape Town: Purnell & Sons, 1973.

Mostert 1992
Mostert, Noël. *Frontiers: The Epic of South Africa's Creation and the Tragedy of the Xhosa People.* New York: Alfred A. Knopf, 1992.

Nel 2000
Nel, Karel. "Headrests and Hairpins: Signifying More Than Status," 151–59. In Roy Sieber and Frank Herreman, eds., *Hair in African Art and Culture.* Exh. cat. New York: Museum for African Art, 2002.

Nel 2002
——. "Consonant with Cattle-Culture: The Art of the Portable," 13–37. In Klopper and Nel 2002.

Nel and Gwintsa 2004
Nel, Karel, and Veliswa Gwintsa. *Glimpses from the South: A Selection of African Art from the Johannesburg Art Gallery.* Exh. brochure. New York: Museum for African Art, 2004.

Nel and Leibhammer 1998
Nel, Karel, and Nessa Leibhammer. "The Puzzle of the Pendant Figures," 151–59. In Dell 1998.

Nettleton 1988
Nettleton, Anitra. "History and the Myth of Zulu Sculpture." *African Arts* 21, 3 (1988): 48–51, 86–87.

Nettleton 1990
——. "'Dream Machines': Southern African Headrests." *South African Journal of Art and Architectural History* 1, 4 (1990): 147–54.

Nettleton 1991
——. "Tradition, Authenticity and Tourist Sculpture in 19th and 20th Century South Africa," 32–47. In *Art and Ambiguity* 1991.

Nettleton 2007
——. "In Search of a Tsonga Style: Figurative and Abstract Woodcarving," 123–37. In Leibhammer 2007.

Odora Hoppers 2004
Odora Hoppers, Catherine A. *Culture, Indigenous Knowledge and Development: The Role of the University.* Johannesburg: Centre for Education Policy Development, [2004].

Pemberton 2008
Pemberton, John, III. *African Beaded Art: Power and Adornment.* Exh. cat. Northampton, Mass.: Smith College Museum of Art, 2008.

Perspectives 1987
Perspectives: Angles on African Art. Exh. cat. New York: Center for African Art, 1987.

Phillips 1995
Phillips, Tom, ed. *Africa: The Art of a Continent.* Exh. cat. London: Royal Academy of Arts; Munich/New York: Prestel, 1995.

Plankensteiner 1998
Plankensteiner, Barbara. *Austausch. Kunst aus dem südlichen Afrika um 1900.* Exh. cat. Vienna: Museum für Völkerkunde, 1998.

Priebatsch 1980
Priebatsch, Suzanne. Exhibition review of "Designs of the Ndebele." *African Arts* 13, 3 (1980): 81.

Proctor and Klopper 1993
Proctor, André, and Sandra Klopper. "Through the Barrel of a Bead: The Personal and the Political in the Beadwork of the Eastern Cape," 57–65. In Bedford 1993.

Ravenhill 1991
Ravenhill, Philip L. *The Art of the Personal Object.* Exh. cat., National Museum of African Art. Washington, D.C.: Smithsonian Institution, 1991.

Robbins and Nooter 1989
Robbins, Warren M., and Nancy Ingram Nooter. *African Art in American Collections.* Washington, D.C.: Smithsonian Institution, 1989.

Schneider 1992
Schneider, Elizabeth Ann. Exhibition review of "Art and Ambiguity: Perspectives on the Brenthurst Collection of Southern African Art." *African Arts* 25, 4 (1992): 91–93.

Schneider 1998
——. "Ndebele Umndwana: Ndebele Dolls and Walls," 139–49. In Dell 1998.

Shooter 1857
Shooter, Joseph. *The Kafirs of Natal and the Zulu Country.* London: E. Stanford, 1857.

Sieber 1972
Sieber, Roy. *African Textiles and Decorative Arts.* Exh. cat. New York: Museum of Modern Art, 1972.

Sieber 1980
——. *African Furniture and Household Objects.* Exh. cat. Bloomington/ London: Indiana University Press; New York: American Federation of Arts, 1980.

Sotheby's 1990
Sotheby's. *Important Tribal Art.* New York, November 20, 1990.

Sotheby's 1999
——. *African and Oceanic Art from a Private Collection.* New York, May 25, 1999.

Sotheby's 2000
——. *African Art from the Egon Guenther Family Collection.* New York, November 18, 2000.

Sotheby's 2005
——. *African and Oceanic Art.* New York, November 11, 2005.

Sotheby's 2006
——. *The William W. Brill Collection of African Art.* New York, November 17, 2006.

Sotheby's 2007a
——. *Collection Marc et Denyse Ginzberg. Afrique, l'art des formes.* Paris, September 10, 2007.

Sotheby's 2007b
——. *Collections Jolika et Goldman et divers amateurs.* Paris, December 5, 2007.

Stokes 1999
Stokes, Deborah. "Rediscovered Treasures: African Beadwork at the Field Museum, Chicago." *African Arts* 32, 3 (1999): 18–31, 91.

Turner 1996
Turner, Jane, ed. *The Dictionary of Art.* 34 vols. London: Macmillan, 1996.

Tyrrell 1968
Tyrrell, Barbara. *Tribal Peoples of Southern Africa.* Cape Town: Gothic Printing, 1968.

Valentin 2002
Valentin, Manuel. "L'Afrique du Sud, la rencontre de plusieurs peuples," 24–33. In Joubert and Valentin 2002.

Van Schalkwyk 1996
Van Schalkwyk, Len. "Origins," 11–16. In Wood 1996.

Van Wyk 1994
Van Wyk, Gary. "Convulsions of the Canon: 'Convention, Context, Change' at the University of the Witwatersrand Art Galleries." *African Arts* 27, 4 (1994): 54–67, 95–96.

Van Wyk 1998
——. "Fertility Flowers of Femininity: South Sotho Fertility Figures," 53–67. In Dell 1998.

Van Wyk 2003
——. "Illuminated Signs: Style and Meaning in the Beadwork of the Xhosa- and Zulu-Speaking Peoples." *African Arts* 36, 3 (2003): 12–33, 93–94.

Vogel 1988
Vogel, Susan. "Introduction," 11–17. In *Art/Artifact: African Art in Anthropology Collections.* Exh. cat. New York: Center for African Art, 1988.

Vogel and Nettleton 1985
Vogel, Catherine A. M., and Anitra C. E. Nettleton. "The Arts of Southern Africa." *African Arts* 18, 3 (1985): 52–53.

Walker 1999
Walker, Roslyn Adele, ed. *Selected Works from the Collection of the National Museum of African Art.* Washington, D.C.: National Museum of African Art, Smithsonian Institution, 1999.

Wanless 1991
Wanless, Ann. "Public Pleasures: Smoking and Snuff-taking in Southern Africa," 126–43. In *Art and Ambiguity* 1991.

Webb 1992
Webb, Virginia-Lee. "Fact and Fiction: Nineteenth-Century Photographs of the Zulu." *African Arts* 25, 1 (1992): 50–59, 98–99.

Wood 1996
Wood, Marilee, ed. *Zulu Treasures: Of Kings and Commoners. A Celebration of the Material Culture of the Zulu People.* Exh. cat. Ulundi: KwaZulu Cultural Museum; Durban: Local History Museums, 1996.

Wood 1998
——. "The Sorghum Child: South Sotho Child Figures," 35–51. In Dell 1998.

Zaloumis and Difford 2000
Zaloumis, Alex, and Ian Difford. *Zulu Tribal Art.* Cape Town: AmaZulu, 2000.

LENDERS TO THE EXHIBITION

Anonymous

Dr. Ronald Adelman

Betsy S. Aubrey and E. Steve Lichtenberg

The Cleveland Museum of Art

Blanche and Charles Derby

Drs. Noble and Jean Endicott

Dede and Oscar Feldman

Randy Fertel

Harry and Diane Greenberg

Jane and Gerald Katcher

Florence Morris

National Museum of African Art, Smithsonian Institution, Washington, D.C.

Timothy Phillips

Suzanne Priebatsch

Suzanne Priebatsch and Natalie Knight

Dori and Daniel Rootenberg, Jacaranda Tribal, New York

Rosemary and Michael Roth

Bill and Gale Simmons

Dr. Gary van Wyk and Lisa Brittan, Axis Gallery, New York

Patricia and Robert Weiner

Frank F. Williams